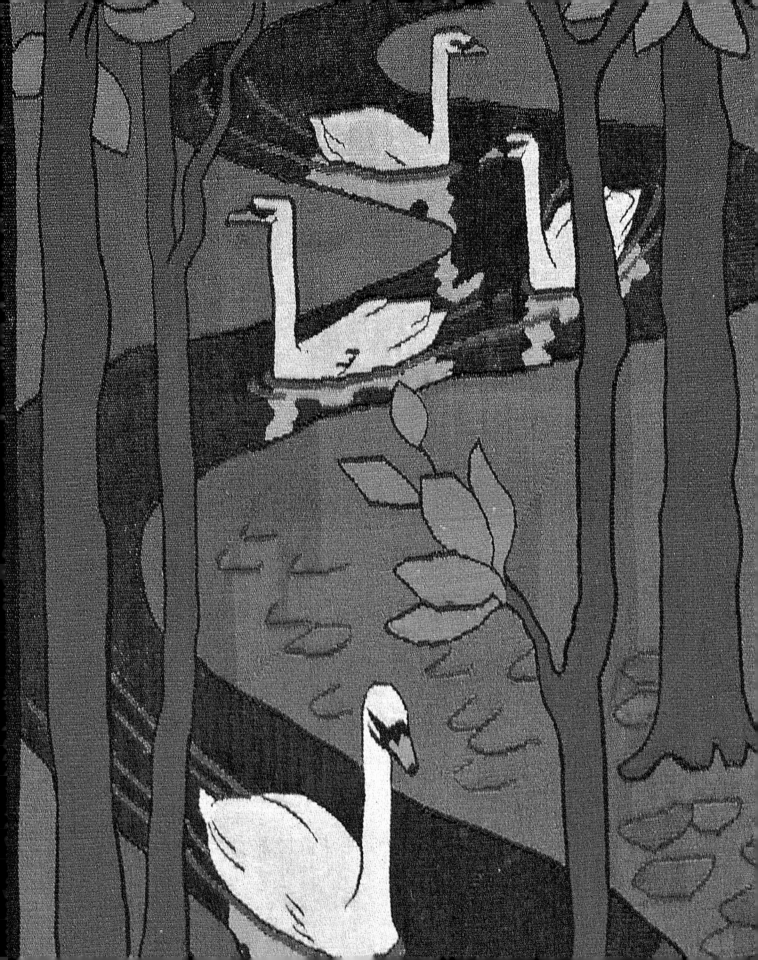

LOOKING EAST
WESTERN ARTISTS AND THE ALLURE OF JAPAN

HELEN BURNHAM

with contributions by Sarah E. Thompson and Jane E. Braun

MFA Publications

Museum of Fine Arts, Boston

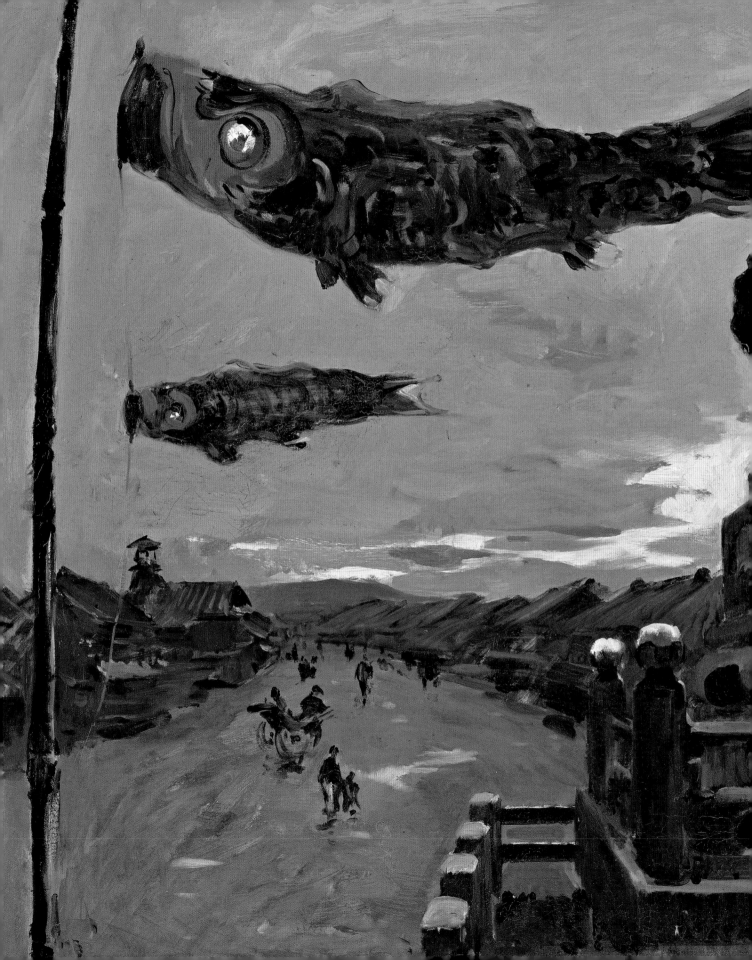

CONTENTS

DIRECTORS' FOREWORD

Looking East celebrates the extraordinary influence of Japanese art and culture on the Western imagination in the late nineteenth and early twentieth centuries. When the island nation opened to international trade in the 1850s after centuries of isolation, a craze for all things Japanese swept Europe and North America. The phenomenon, known as *japonisme*, profoundly affected leading artistic movements of the era, Impressionism, Aestheticism, and Art Nouveau among them.

This publication accompanies the first major exhibition from the collections of the Museum of Fine Arts, Boston, to survey the rich connections among Japan, Europe, and North America around 1900. Bostonians at the turn of the century donated to the MFA superb examples of Japanese art, founding a collection that is among the finest in the world. The Museum's renowned holdings of European and American art from that period include masterpieces that display with exceptional vitality the influence of the Japanese prints, lacquerware, and other imports increasingly available to Westerners in the Gilded Age. We are proud to present selections from the collection of the great Japanophile William Sturgis Bigelow; landscapes by Claude Monet from the Museum's cache of his paintings, unrivaled outside of Paris; Vincent van Gogh's celebrated *Postman Joseph Roulin*; and other highlights that rank among the MFA's most beloved treasures. We are grateful to be able to showcase recent gifts, purchases, and loans made possible by the enduring support of a circle of enthusiastic benefactors, in particular Saundra B. Lane, Jean S. and Frederic A. Sharf, Leonard A. Lauder, and Eijk and Rose-Marie van Otterloo.

A fascination with japonisme is very much a twenty-first-century phenomenon in Nashville, and we are extremely pleased that this important exhibition will be seen at the Frist Center for the Visual Arts. A sizeable Japanese

community lives in and around Nashville, which hosts an annual Cherry Blossom Festival, and some 370 Japanese companies operate in the area.

We are also happy to be able to present *Looking East* at the Musée National des Beaux-Arts du Québec, which is about to open a new pavilion designed by the firm Office for Metropolitan Architecture, together with Provencher Roy + Associés Architectes. It will be the first survey exhibition on the subject in Canada, and we feel privileged to be able to introduce it to our visitors through these stunning works of art.

San Francisco's Asian Art Museum is an excellent venue for this extraordinary exhibition celebrating the deep currents of Japanese influence in North American and European art. The discourse between Asia and North America is a defining element in San Francisco's cultural identity and the vibrant ties between Japan and San Francisco give the exhibition's themes special resonance.

It is fitting that a project of such cross-cultural significance is an international collaboration. As the exhibition travels throughout North America and Japan, it is a great pleasure to share this offshoot of a long and fruitful relationship with Japan with our friends around the world.

Malcolm Rogers
Ann and Graham Gund Director
Museum of Fine Arts, Boston

Line Ouellet
Executive Director
Musée National des Beaux-Arts du Québec

Susan H. Edwards
Executive Director and Chief
Executive Officer
Frist Center for the Visual Arts

Jay Xu
Director and Chief Executive Officer
Asian Art Museum

ACKNOWLEDGMENTS

This exhibition has been a true collaboration, dependent on numerous colleagues and friends to ensure its success. First and foremost among them are Jane Braun and Sarah Thompson, who have been partners in every respect and who have contributed thoughtful essays to this publication.

I appreciate the support of the Department of Prints, Drawings, and Photographs and in particular of Clifford Ackley, Chair and Ruth and Carl J. Shapiro Curator of Prints and Drawings; Anne Havinga, Estrellita and Yousuf Karsh Senior Curator of Photographs; Karen Haas, Lane Curator of Photographs; Kate Harper; Benjamin Weiss, Leonard A. Lauder Curator of Visual Culture; Patrick Murphy, Lia and William Poorvu Curatorial Research Fellow and Supervisor, Morse Study Room; Stephanie Stepanek; and Barbara Stern Shapiro, whose deep knowledge of japonisme has been an invaluable resource. Meghan Melvin, Jean S. and Frederic A. Sharf Curator of Design, was especially supportive in the late stages of the exhibition.

Our colleagues in the Art of Europe department provided invaluable recommendations and graciously found ways to make paintings and decorative arts available to the project. We are especially grateful to George T. Shackelford, former Arthur K. Solomon Curator of Modern Art, and to Thomas Michie, Russell B. and Andrée Beauchamp Stearns Senior Curator of Decorative Arts and Sculpture. Emily Beeny, Martha Clawson, Deanna Griffin, Rebecca Tilles, and Leah Whiteside have been very helpful.

The exhibition would not have been possible without the kind advice and goodwill of curators in the Art of the Americas department, principally Elliot Bostwick Davis, John Moors Cabot Chair; Erica Hirshler, Croll Senior Curator of American Paintings; and Nonie Gadsden, Katherine Lane Weems

Senior Curator of American Decorative Arts and Sculpture. All of them found time for *Looking East* even as they were putting the finishing touches on their superb new wing.

Thank you to Lauren Whitley and William DeGregorio in the David and Roberta Logie Department of Textile and Fashion Arts.

In addition to Sarah Thompson, a number of members of the Department of Art of Asia, Africa, and Oceania have been instrumental to the exhibition. Anne Nishimura Morse, William and Helen Pounds Senior Curator of Japanese Art, gave insightful suggestions on the checklist, while Angie Simonds and Ellen Takata generously lent their time and expertise to finding appropriate objects in the collection.

In the Museum's libraries and archives, Lauren Kimball-Brown carefully tracked obscure books and articles, and Paul McAlpine shared his expertise on Japanese postcards, photographs, and visual culture.

The dedicated conservators and collections care specialists involved with the exhibition include Alison Luxner and Gail English, who were instrumental to the conservation and framing of the works on paper. Thank you also to the talented paintings conservators Rhona MacBeth, Eijk and Rose-Marie van Otterloo Conservator of Paintings and Head of Paintings Conservation, and Irene Konefal. Special praise is due to the dedicated staff of Asian Conservation: Jacki Elgar lent early advice and support, and Joan Wright, Bettina Burr Conservator, and John Robbe have played major roles in the care of the Japanese woodblock prints on display. I am likewise grateful to Hsin-Chen Tsai and generous volunteers Trustee Bettina Burr and Jo-Ann Pinkowitz in Asian Conservation. Gordon Hanlon, Andrew Haines, Christine Schaette, and Caitlin Sofield sensitively prepared the frames and furniture, while Abigail Hykin and Brett Angell have seen to the beautiful presentation of the objects in the exhibition.

Anna Bursaux has helped ensure the success of the exhibition with much appreciated gusto. Siobhan Wheeler and Chris Hightower, have ably coordinated myriad details within the Museum and with our traveling partners.

Anna Barnet has been a discerning and patient editor and Jennifer Snodgrass has handily provided editorial support. Steven Schoenfelder has given this book its beautiful design; Terry McAweeney oversaw its production; and

Chris DiPietro managed its distribution. Emiko Usui, Director of MFA Publications, has offered good humor and encouragement throughout the process.

For lending their time and expertise, I am grateful to Mary S. Bartow and Jason Herrick of Sotheby's, as well as to Gordon Cooke of The Fine Art Society Plc. Monica Bincsik advised on the selection of lacquerware. Gabriel and Yvonne Weisberg discussed the exhibition idea with me and offered helpful advice for its development; their published research on japonisme has been an invaluable resource.

Mark Scala of the Frist Center for the Visual Arts in Nashville, Tennessee, has been an enthusiastic advocate of the exhibition from an early stage in its planning, encouraging its ambitious scale and scope. I appreciate his support and the professionalism of the staff in Nashville, in particular the insightful approach of curator Trinita Kennedy, who installed the exhibition in its first iteration. Thank you also to the staff of the Musée National des Beaux-Arts du Québec, especially curator Daniel Drouin, as well as to curator Laura Allen and the team at San Francisco's Asian Art Museum, where the North American tour culminates by looking west, instead of east, to Japan.

Helen Burnham
Pamela and Peter Voss Curator of Prints and Drawings

INTRODUCTION
THE ALLURE OF JAPAN

HELEN BURNHAM

In the late nineteenth century, a generation of artists and collectors across Europe and North America embraced the allure of Japan. The art and culture of the island nation suddenly became fashionable in the West: its goods appeared in curiosity shops and department stores; its culture went on display in exhibitions; and its artistic heritage became a focus of conversation in academies, cafés, and salons. Stimulated by the arrival on Western shores of awe-inspiring unfamiliar objects, including lacquerware, bronzes, kimono, and woodblock prints, the taste for Japan grew in tandem with its increased presence in the public sphere. It became a phenomenon known as *japonisme*, which was in turn a vague sensibility and a potent influence, a private tendency and a public mania, a subtle catalyst and a sweeping force central to the story of Western art in the modern era.

After centuries of self-imposed isolation, Japan fully opened to international trade in the late 1850s. Commodore Matthew C. Perry of the United States and a forbidding fleet known as the Black Ships landed in Edo Bay in 1853, forcing the ruling Tokugawa dynasty to abandon a policy that had largely succeeded in preventing foreigners from entering the country for centuries (fig. 1). The Japanese signed trade agreements with Western nations, beginning a new era of engagement with the outside world. The ensuing decades witnessed a striking increase in exports as well as a Japanese campaign to shape its image abroad by sending emissaries to foreign cities such as Paris, Boston, and New York and by participating in such high-profile events as the celebrated World's Fairs.

The arts of Japan had been present in the West well before the 1850s, in great part thanks to the Dutch, who were the only Europeans allowed to trade with Japan during the

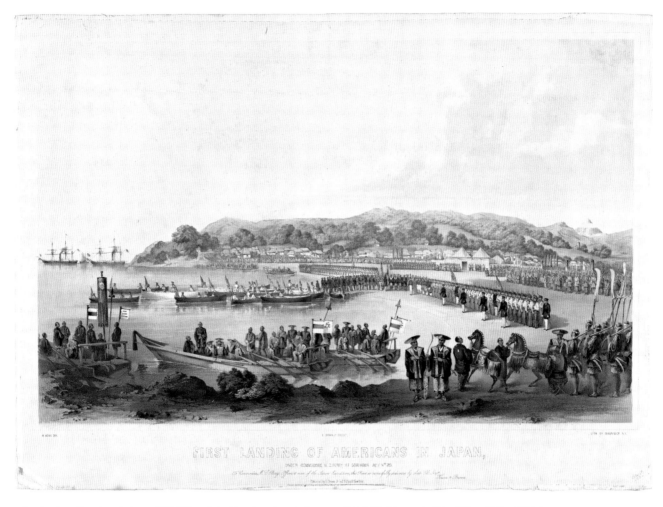

1. *First Landing of Americans in Japan,* 1855. William Heine (American, born in Germany, 1827–1885). Lithograph, 62.5 × 87.3 cm (24⅝ × 34⅜ in.)

preceding two hundred years. In the 1830s Philipp Franz von Siebold, a German doctor who had worked for the Dutch East India Company, published a selection of the textiles, porcelain, and other objects in circulation during this period, yet these goods, in their limited numbers, remained the focus of a select few and never sparked a reaction equivalent to the enthusiasm of the late nineteenth century.

Many experienced the early days of japonisme as a period of intense revelation. Japan came into vogue at a moment ripe for alternatives to the cultural status quo. Influential critics believed that the fine and decorative arts were stagnating, and they recommended historic and exotic styles as antidotes, in particular those from what were considered the Near and Far East. Both regions were known in that period as the Orient, and the term *Orientalism* emerged in reference to the study or depiction of their cultures by Westerners.

Popular writers alerted readers to the newest modes in dress and interior decor, including Japanese goods among the desirable must-haves for the rising urban classes. Japan had become trendy, but while its goods fed a taste for novelty, they also proved capable of profoundly challenging entrenched artistic habits.

Western artists responded to Japan in a variety of ways. Many adopted formal qualities that grew into hallmarks of japonisme: asymmetry, broad areas of color and pattern, expressive stylized lines, abstraction, and emphasis on the flatness of the picture plane. Yet some with deeply felt connections to the country employed few if any of these devices, and others mingled Japanese styles with different traditions—folk, medieval, and Islamic, to name a few—producing a mélange of cultural borrowings that would become part of the standard repertoire of the avant-garde.

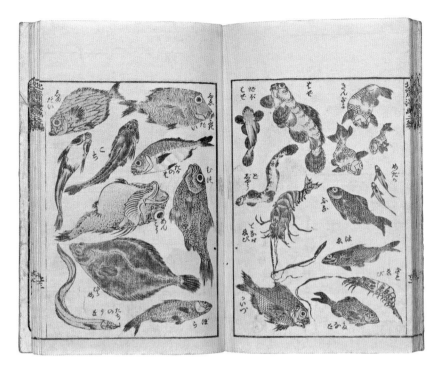

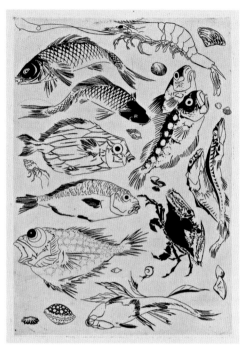

2. *Fish* from the book *Hokusai Sketchbooks, Volume Two* (*Hokusai manga nihen*), about 1815–1868. Katsushika Hokusai (Japanese, 1760–1849). Woodblock-printed book, 22.6 × 15.6 cm (8⅞ × 6⅛ in.)

3. *Fish Patterns for the Service Rousseau,* 1866. Félix Bracquemond (French, 1833–1914). Etching, 35 × 25 cm (13¾ × 9¹³⁄₁₆ in.)

A competitive fervor inflamed aficionados who vied to assert the claim that they were the first to recognize the beauty of the country's art. Seeing things differently was part of the pleasure—and prestige—of looking at the modern world through a Japanese lens. The story of the printmaker Félix Bracquemond, among the earliest French artists of his generation to discover the wonders of Japanese woodblock prints, suggests the significance in the early days of japonisme of having the pioneering vision to appreciate new and unfamiliar things.

Bracquemond first saw a group of Japanese printed images in the studio of a Parisian friend, possibly as early as 1856. They appear to have been examples of Katsushika Hokusai's books of *manga,* a term used at the time to describe informal sketches or drawings.* These lighthearted pictures could be used as models for amateur painters or enjoyed on their own. Hokusai was one of the most important artists of the *ukiyo-e* school, which flourished during the Edo period (1615–1868), a

time of unprecedented prosperity for the urban middle classes. Their pleasurable diversions, known collectively as the "Floating World," or *ukiyo,* had a great deal in common with the entertainments of modern Paris—surely one of the reasons that ukiyo-e imagery appealed to Bracquemond and his circle.

Imitating motifs was one of the first ways that Western artists introduced Japanese elements into their work. Excited by the new possibilities offered by the foreign forms, Bracquemond copied from many books and ukiyo-e woodblock prints. He drew a number of his designs for porcelain, including the 1866 *Fish Patterns for the Service Rousseau,* from Hokusai and his followers (figs. 2 and 3).¹ Philippe Burty, the critic who coined

Japanese names appear in traditional style, with surnames preceding given or artistic names. Subsequent mentions use the artistic name for those active only in Japan and surname for those who also were active in the West.

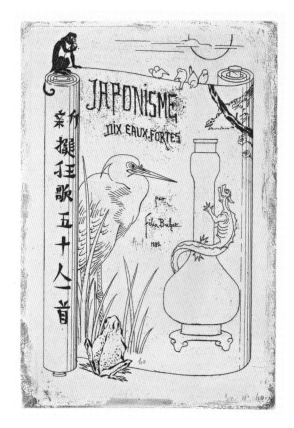

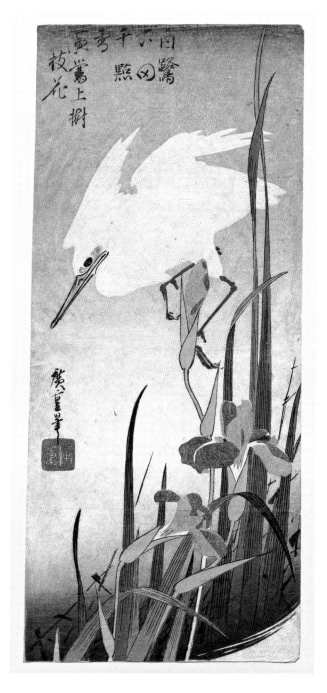

4. Title page from the portfolio *Japonisme*, 1883. Félix H. Buhot (French, 1847–1898). Etching, 26.1 × 17.6 cm (10¼ × 6¹⁵⁄₁₆ in.)

5. *White Heron and Iris*, 1830s. Utagawa Hiroshige (Japanese, 1797–1858). Woodblock print, 37.3 × 16.3 cm (14¹¹⁄₁₆ × 6⁷⁄₁₆ in.)

the term japonisme in 1872, strongly advocated this kind of close attention to Japanese art. He encouraged the practice as a means to revitalize what seemed to him a moribund Western tradition, flagging particularly in the decorative arts.

Like many of his peers, Burty was a voracious collector of Japanese prints and objects. Selections from his holdings appear in an 1883 portfolio of etchings by Félix Buhot. The title page displays a certain kind of japonisme somewhat akin to eighteenth-century chinoiserie: a whimsical assortment of Asian creatures, motifs, and symbols transcribed from various sources and combined to provoke delight in their intended Western audience. Japanese prototypes can be identified for many of Buhot's charmingly unassuming details (fig. 4). His standing bird has close companions in the herons of Japanese woodblock prints, such as this one by Utagawa Hiroshige, another great ukiyo-e artist (fig. 5). The toad in Buhot's etching is a lively version of a bronze inkwell in Burty's collection, and

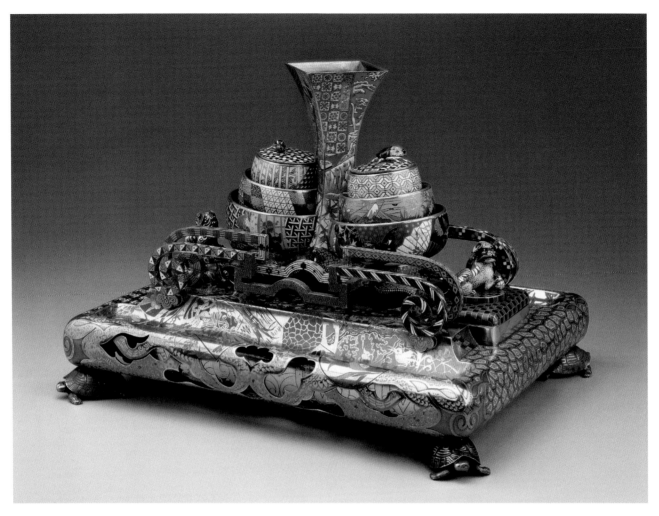

6. Inkstand, 1876. Designed by Paul Legrand (French, 1840–1910). Manufactured by the firm of Frédéric Boucheron, Paris. Silver, partial gilt, champlevé, basse-taille, cloisonné enamels, 23.4 × 33.6 cm (9¼ × 13¼ in.)

the Japanese characters are the title of a book of poetry, transcribed (by a hand illiterate in Japanese, presumably Buhot's) from its cover.[2]

Eclectic groupings of Japanese motifs featured heavily in early manifestations of japonisme. An extraordinary inkstand manufactured in 1876 by the highly successful (and still extant) Parisian firm of Frédéric Boucheron, after designs by Paul Legrand, is an imaginative example (fig. 6). It teems with patterns and images borrowed from woodblock prints, lacquerware, sword guards, and textile stencils. Boucheron and Legrand, a designer known for his distinctive, colorful style, would have had access to these items in Paris at curiosity shops and in the collections of friends. Boucheron is believed to have been a member, along with Bracquemond and Burty, of a secretive japoniste society with the faux-Oriental name Jing-lar. The group gathered regularly with the purported goal

of studying Japan, apparently a disguise for its true purpose: to discuss leftist politics, eat heartily, and delight in the company of like-minded friends.[3]

In a similarly playful spirit, the inkstand dresses up as Japanese for the pleasure of Western audiences. The interiors of the ink and sand pots, which resemble miniature stacked bowls, have been enameled in imitation of celadon glazes. The elaborate decoration, probably inspired by such novelties as imported sword guards embellished with insects, is united by intricate patterns, in the vein of the textile stencils that were imported in great number (figs. 7 and 8).[4] These elements appear together in unusual and wildly abundant juxtapositions, unlikely in Japanese art but in keeping with a Western interior decorating trend dubbed *horror vacui*, or fear of empty spaces.

The richly decorated inkstand is a product of a rage for art and design described by Charles Louis Tiffany as striving to be

7. Sword guard with design of insects, late 18th–early 19th century. Hirata Narisuke (Japanese, died in 1816). Copper and gold alloy (*shakudō*) with enamels and gold, 7.1 × 6.3 × 0.4 cm (2¾ × 2½ × ¼ in.)

8. Textile stencil. Japan, 19th century. Cut mulberry paper, 25.7 × 40.5 cm (10⅛ × 15¹⁵⁄₁₆ in.)

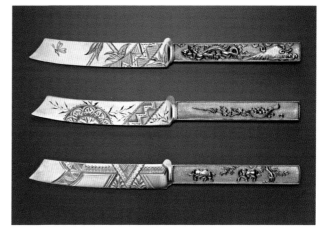

9. Knives with *kozuka*-style handles, about 1881. Manufactured by the Gorham Manufacturing Company, Providence, RI. Silver with gilding, each knife: 19.7 × 2 cm (7¾ x ¾ in.)

"even more Japanese than the Japanese themselves."[5] This was a taste that the Japanese quickly recognized. The Meiji government, inaugurated in 1868, fostered the creation of goods calculated to please Western customers. For instance, Japanese craftsmen almost certainly made the handles, designed in an animated fashion to appeal to American customers, for a set of knives manufactured about 1881 by Gorham Manufacturing Company of Rhode Island. Small utility knives known as *kozuka*, which had long been highly valued craft objects in Japan, were traditionally cast from fine metals, especially bronze. After the opening of Japan, craftsmen produced *kozuka* for foreigners, who sometimes used the handles to make Western dining knives. Eventually, the Japanese sold the handles alone, crafting them from lower-quality metals with die-stamped decoration gilded in select areas, as is the case here.[6] Gorham added silver blades of their own design, decorated with butterflies, fans, and geometric patterns (fig. 9). The resulting dessert knives are lively Victorian showpieces, unrestrained in their glittering exotic motifs and materials.

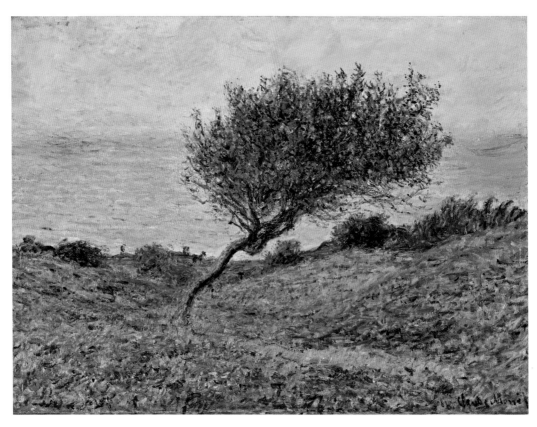

10. *Seacoast at Trouville,* 1881. Claude Monet (French, 1840–1926). Oil on canvas, 60.7 × 81.3 cm (23⅞ × 32 in.)

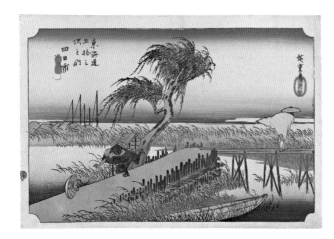

11. *Yokkaichi: Mie River* from the series *Fifty-three Stations of the Tōkaidō Road,* about 1833–1834. Utagawa Hiroshige (Japanese, 1797–1858). Woodblock print, 25.2 × 37 cm (9¹⁵⁄₁₆ × 14⁹⁄₁₆ in.)

Each painter of the era borrowed from Japanese art "the qualities with the closest affinities to his own talents."[7] Claude Monet, for example, found in it alternatives to the pervading clichés of academic art. Monet occasionally based his work on particular ukiyo-e prints from his large collection. These "sources" were far less pronounced in his paintings, however, than those in the Gorham knives or Boucheron inkstand. Instead, it was his unusual approach to color and composition that struck his contemporaries as Japanese. In paintings like *Seacoast at Trouville* (1881), Monet moved away from the use of perspective and shading, established Western tools for the organization of convincing representation (fig. 10). He blocked the expected vanishing point of his composition with an expressive tree and emphasized bands of vibrant color to activate the surface of the canvas, while reinforcing its overall integrity. Monet learned these lessons from masters of

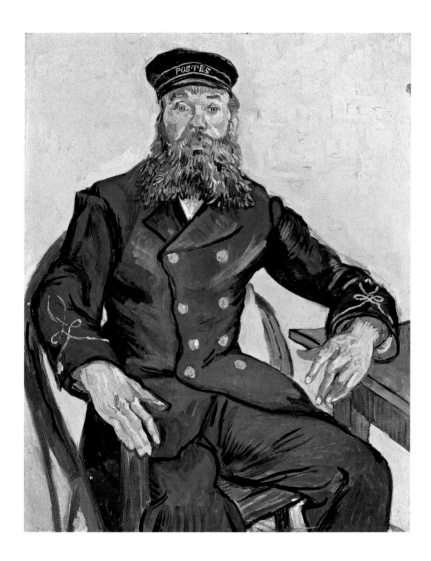

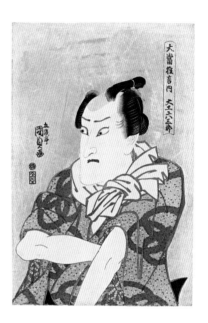

12. *Postman Joseph Roulin*, 1888. Vincent van Gogh (Dutch, worked in France, 1853–1890). Oil on canvas, 81.3 × 65.4 cm (32 × 25¾ in.)

13. *Actor Onoe Matsusuke II as the Carpenter Rokusaburō* from the series *Great Hit Plays,* about 1814. Utagawa Kunisada (Japanese, 1786–1864). Woodblock print, 38.9 × 25.9 cm (15⁵⁄₁₆ × 10³⁄₁₆ in.)

ukiyo-e, including Hiroshige, whose well-known *Yokkaichi: Mie River* (fig. 11) from about 1833–1834 is remarkably similar in composition to *Seacoast at Trouville*, and broadly incorporated them into a new conception of landscape.

Vincent van Gogh believed that Japan, a land he never visited, was a utopia where the sun shone brightly and painters worked together in monastic harmony. "My whole work is founded on the Japanese," Van Gogh wrote in 1888 from Arles, where he envisioned creating a French version of Japan.[8] There he befriended the postal worker Joseph Roulin, of whom he made six portraits. In this 1888 version, believed to be the first, Roulin's face has become a vibrant mask while his gnarled fingers torque into a kind of hieratic gesture, as stylized as those of actors in Kabuki drama, a major category of ukiyo-e prints (figs. 12 and 13). In his paintings Van Gogh meshed Japanese elements with other qualities that he considered "primitive," a term that had specific connotations for him and his contemporaries. It was used to describe Western folk and pre-Renaissance art, including ancient Greek, as well as art from non-Western cultures ranging from African to Oceanic. Though often derogatory and rooted in racism, much like the idea of the "noble savage," the notion of the primitive could also be used to suggest pure, powerful, and mystical traits. The color contrasts and broad spatial divisions in *Postman Joseph Roulin* are familiar from Japanese woodblock prints, but they are also similar to medieval stained glass and cloisonné, as well as the raw and intensely expressive drawing styles of artists working for the popular press.

Japanese elements and motifs were often knit with those of other cultures to create late nineteenth-century styles, including Art Nouveau. The Paris Universal Exposition of 1900 was a high point of this style, which the dealer Siegfried Bing

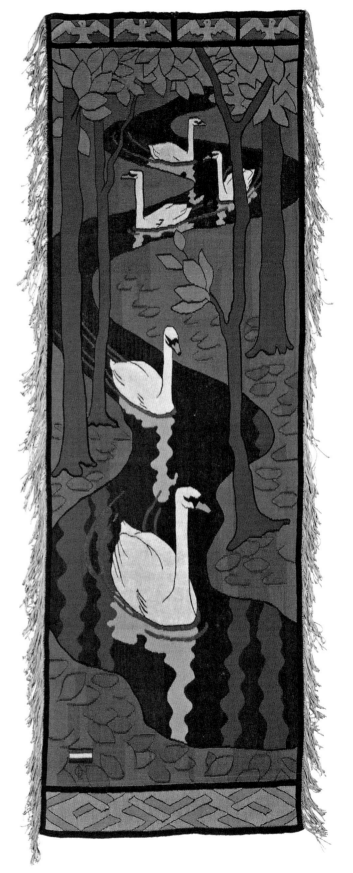

14. *Five Swans,* 1897. Designed by Otto Eckmann (German, 1865–1902). Woven by the Kunstgewerbeschule Scherrebek. Wool and cotton tapestry, 241.3 × 107.3 cm (95 × 42¼ in.)

fostered in his eponymous Parisian gallery, L'Art Nouveau, and in a special pavilion at the exposition. A champion of japonisme, he also published a monthly periodical titled *Le Japon artistique*. Great examples of the style sometimes derived inspiration from the reproductions of Japanese art in that journal. That may have been the case for the Munich-based artist Otto Eckmann, whose *Five Swans* was an icon of Jugendstil, also known as German Art Nouveau (fig. 14). Eckmann, who designed furniture for Siegfried Bing's 1900 pavilion,[9] was one of the founders of Jugendstil, and his 1897 tapestry design, which was shown at the exposition to great critical acclaim, is typical of its eclecticism. Its sinuous and bold outlines, long vertical format, abstraction, repetition, and geometric patterning borrow from Japanese woodblock prints and hanging scroll paintings, known as *kakemono*, as well as from the decorative lines and patterns of medieval German tapestries and prints.

15. *Water* from the series *The Elements,* 1898. Gisbert Combaz (Belgian, 1869–1941). Postcard, 9 × 14 cm (3⁹⁄₁₆ × 5½ in.)

Artists inspired by Japan worked in a range of media, including commercial forms like the poster and the newly introduced postcard, which were both immensely popular toward the end of the nineteenth century. In an 1898 postcard series designed for the Brussels art publisher Dietrich et Cie, the Belgian artist Gisbert Combaz drew his swirling Art Nouveau compositions from the aesthetics of Japanese woodblock prints (fig. 15). Combaz believed art could have an elevating effect on viewers and had faith in the importance of the so-called low or useful arts; he designed posters, ceramics, and wallpaper in addition to postcards. This inclusive perspective corresponds with contemporary views of Japan as a place where art affected every level and aspect of existence, where "art pours out of daily life, where everything exists in a dream of endless beautiful flow."¹⁰ Such romantic views of Japan often persisted even in the face of the reality of a quickly changing country.

Many Westerners journeyed to Japan as it undertook a campaign of intense modernization. Among those travelers were early supporters of the Japanese collections at the Museum of Fine Arts, Boston, which became the most important outside Japan during this period, thanks in great part to their efforts. Edward Sylvester Morse, William Sturgis Bigelow, and Ernest Fenollosa, with their Japanese colleague Okakura Kakuzō, were leaders among those who sought to preserve the artifacts of a disappearing culture, protecting rare objects and paintings, and conserving folklore and traditional rituals, such as the tea ceremony. The majority of tourists, however, gathered inexpensive souvenirs, including photographs of famous historic sites.

Artists recorded their travels in sketches and paintings with varying degrees of accuracy. Louis Dumoulin's *Carp Banners in Kyoto* is one of a series of paintings inspired by the artist's trip

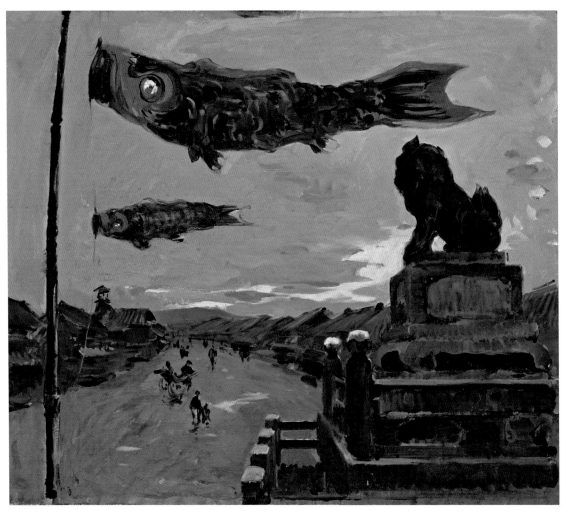

16. *Carp Banners in Kyoto* (*Fête des Garçons*), 1888. Louis Dumoulin (French, 1860–1924). Oil on canvas, 46 × 54.3 cm (18⅛ × 21⅜ in.)

to Asia in 1888 and 1889 (fig. 16). Initially the artist called the work *Boys' Festival in Yokohama*, but the painting was actually based on a photograph of Kyoto taken about 1886 by Adolfo Farsari, an Italian photographer living in Yokohama in the 1880s who specialized in hand-colored photographs for the Western tourist trade (fig. 17).[11] In the foreground Dumoulin added carp banners, which are typically flown in celebration of male children but unlikely in this location. With this addition the painting became his personal, confused version of "Yoko-hama"—a composite of mistaken memories grounded in references to seemingly recognizable places and customs quoted from photographs and, perhaps, woodblock prints (fig. 18).

In contrast to Dumoulin's loose interpretation of reality, the American watercolorist Henry Roderick Newman meticulously rendered a detail of the mausoleum of Ieyasu at Nikko, the tomb of the founder of the Tokugawa shogunate,

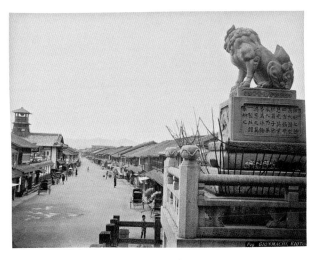

17. *View of Shijō-dori, Kyoto*, about 1886. Adolfo Farsari (Italian, 1841–1898). Photograph, 19.2 × 24.2 cm (7⁹⁄₁₆ × 9½ in.)

18. *Suidō Bridge and Surugadai*
from the series *One Hundred
Famous Views of Edo*, 1857.
Utagawa Hiroshige (Japanese,
1797–1858). Woodblock print,
35.7 × 24.5 cm (14¹⁄₁₆ × 9⅝ in.)

19. *Wall Enclosing the
Mausoleum of Ieyasu at Nikko,
Japan*, 1897. Henry Roderick
Newman (American, 1843–1917).
Watercolor, 41.9 × 48.3 cm
(16½ × 19 in.)

which had become a key tourist destination by 1897, the year
Newman visited Japan (fig. 19). He employed the same precise
technique in this watercolor that he brought to his depiction
of sites in Egypt and Italy, focusing on the faithful transcrip-
tion of an identifiable locale. Newman's concern was to val-
idate watercolor as a serious artistic medium; he left little
room for flights of fancy. Yet, in its own way, his vision was as
idealistic as Dumoulin's, as he depicts a Japan untarnished by
contact with the outside world.

Other artist-travelers focused on the possibility of a pro-
found engagement with Japanese art and culture rather than
the re-creation of sites and monuments. Arthur Wesley Dow's

20. *Bend of a River,* about 1898. Arthur Wesley Dow (American, 1857–1922). Woodcut, 23 × 6.1 cm (9¹⁄₁₆ × 2⅜ in.)

voyage in 1903 was the pinnacle of a long-lasting and deeply influential relationship that began in Boston in the early 1890s, when he came across reproductions of Japanese woodblock prints. "One evening with Hokusai," he later recalled, "gave me more light on composition and decorative effect than years of study of pictures."[12] He devoted himself to investigating the principles of Japanese art, working as an assistant and then as a curator in the Japanese department at the Museum of Fine Arts, Boston. Ultimately, Dow translated those principles for his contemporaries and students in a book titled *Composition*, originally published in 1899. A standard of art education in the early twentieth century, *Composition* relies on three fundamental tenets of art, "Line—Notan—Color"; "Notan" is roughly translated from the Japanese as tonality, or the balance between light and dark.

Composition is heavily illustrated with Japanese works of art, many of which could have inspired Dow's small woodcuts

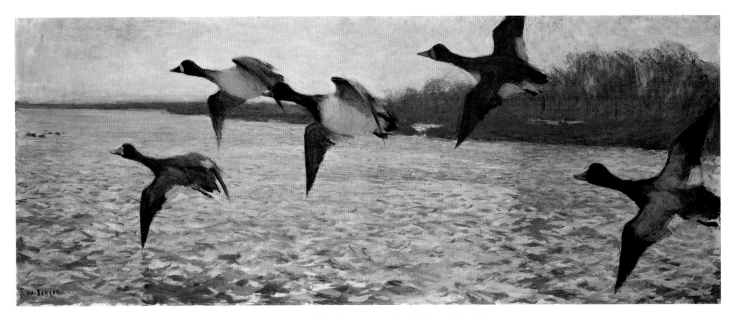

21. *Early Morning*, about 1899. Frank Weston Benson (American, 1862–1951). Oil on canvas, 61.3 × 152.7 cm (24⅛ × 60⅛ in.)

of Ipswich, Massachusetts. Dow held summer art classes in Ipswich and was known for encouraging numerous female students, including Georgia O'Keeffe. He often taught using Japanese albums and paper, brushes and inks supplied by Matsuki Bunkyo, a renowned art dealer and his friend and neighbor in Salem, Massachusetts. The vertical format of his 1898 *Bend of a River* resembles the slim vertical format of a kakemono (fig. 20). The sinuous curve of the water flows upward toward the top of the print, instead of receding into space as in traditional Western perspective, and the abstract tree is placed asymmetrically, the balance of colors—green, beige, light pink, and yellow—all very much inspired by Japanese paintings and woodblock prints.

Matsuki was one of the most important dealers of Japanese art in the United States. He had a gallery in Boston in addition to the outpost near Dow in Salem and primarily sold woodblock prints before transitioning to Chinese and Japanese paintings and objects. Yamanaka and Company, which had a gallery in Boston near Matsuki's as well as one in New York, was another major gallery in the United States. The sportsman artist Frank Weston Benson was a client of both dealers. Their trade went two ways: Yamanaka sent some of Benson's etchings to Japan in 1917 through R. S. Hisada, a personal friend. Hisada's friends in Japan reportedly felt that Benson "truly made the birds fly."[13]

It seems likely that Benson's 1899 view of geese flying over a salt marsh (fig. 21) was based, at least in part, on a Japanese screen that the painter may have seen at Matsuki's before it was sold to the major collector Charles Lang Freer in 1898 (fig. 22).[14] The four-panel screen was painted by the eighteenth-century master Maruyama Ōkyo, who was himself influenced by Western art. Is this then a case of influence or affinity? It is difficult to isolate the Japanese aspects of Benson's *Early Morning*, so thoroughly have they been digested.

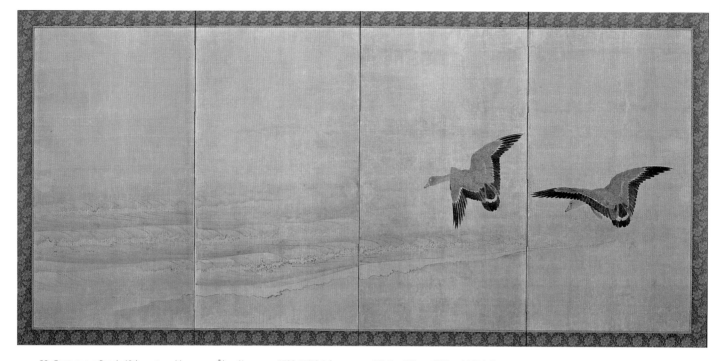

22. *Geese over a Beach,* 18th century. Maruyama Ōkyo (Japanese, 1733–1795). Ink on paper, 176.7 × 372 cm (69⅝ × 146½ in.)

The long horizontal format, the placement of the birds across the picture plane, and the quality of pinkish golden light are suggestive. More telling, however, is the works' shared appreciation for the beauty of an event, witnessed countless times, that marks the passage of the seasons on Cape Cod as well as in Japan. As Benson himself said, "Every artist must . . . see things in his own way. He will do this as the Japanese have done it for centuries—study some object in nature until he can draw it from memory by repeated practice. In that way I learned how birds appear in flight."[15]

By the 1920s japonisme had become part of the basic vocabulary of modern art, in many instances indistinguishable from the many other sources, influences, and stimuli that affected the various movements of the early twentieth century.

Yet artists of this era continued to benefit from engagement with Japanese art and culture, fostered by new ideas and encounters as well as by new priorities for themselves and their work. The Pictorialist photographers in California are especially striking in this respect. They adopted some of the conventions of Japanese art second- and even thirdhand, often through European avant-garde art promoted by Alfred Stieglitz. But they also knew the bohemian Japanophiles Sadakichi Hartmann and Clarence McGehee; saw exhibitions of ukiyo-e prints in Los Angeles; and met the young Japanese American photographers, mostly first-generation immigrants, who formed the Japanese Camera Club of California.[16]

Margrethe Mather, a photographer who was closely involved with the Japanese American Pictorialists, is the subject

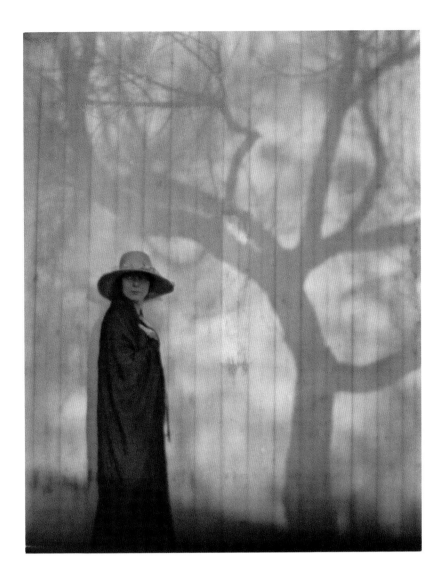

23. *Prologue to a
Sad Spring,* 1920.
Edward Weston
(American, 1886–
1958). Photograph,
23.8 × 18.7 cm
(9⅜ × 7⅜ in.)

of Edward Weston's *Prologue to a Sad Spring* (fig. 23). The 1920 work may be seen as a tribute to Mather and her interest in Asian art, as well as something of an ode to an earlier time of collaboration and romance with Weston. The shadow of the tree against a barn door—its strangely elegant, yet disturbingly gaunt structure flattening and defining the greater part of the composition—might have been borrowed from an ukiyo-e print, while the atmospheric softness of the image evokes James McNeill Whistler, a major interpreter of japonisme. It recalls the style developed by both Mather and Weston some years earlier, when photography came into its own as an artistic practice and the adoption of Japanese-style elements helped link the burgeoning medium to the major currents in avant-garde art.

In the late nineteenth and early twentieth centuries, Western artists looked to Japan as an exotic source of novelty and inspiration. This attraction to the East arose from internal developments in the West, in particular a deeply felt need to find new methods of understanding and representing the modern world. Though it was never a strictly unified style, japonisme became part of the Western artistic vocabulary. The phenomenon contributed to numerous movements, ranging from conservative strands of Orientalism to the most advanced experiments of the avant-garde. Japan became a beacon for a generation of artists who incorporated elements of its artistic, cultural, and spiritual heritage into their creations, which were as evocative of their dreams for the West as of their passion for what they called the Land of the Rising Sun.

FROM THE OTHER SIDE:
JAPANESE PRINTS AT HOME

SARAH E. THOMPSON

24. *Foreign Woman, Heron in a Willow Tree, Englishman Riding a Horse* from the series *Cutout Pictures of Many Lands,* 1861. Utagawa Yoshiiku (Japanese, 1833–1904) with Miyagi Gengyo (Japanese, 1817–1880). Woodblock print, 35.8 × 24.2 cm (14⅛ × 9½ in.)

Japanese color woodblock prints of the eighteenth and nineteenth centuries delighted Western artists, who saw them as extremely exotic, products of a tradition born far from Europe, and thus a potential source of new inspiration in the 1860s, when Western art was challenged by the invention of photography and the stultifying influence of the academy. Japanese prints, more than any other non-Western art form, exerted such an attraction partly because they became plentiful and inexpensive following the establishment of the agreements of 1860 that made Yokohama an international trade port bustling with exotic foreigners of various nationalities (fig. 24).[1] But the presence of familiar elements also made the unfamiliar ones approachable. Whether they realized it or not, Western artists felt relatively comfortable with Japanese prints because they were the products of an urban popular culture that had many points in common with

nineteenth-century European society, and because the formal qualities of the prints had already been influenced by European concepts of illusionistic pictorial space and realistic human anatomy.

Following the arrival of Portuguese explorers in the 1540s, Japan had extensive contact with Europe for almost a century (fig. 25). When the Europeans first arrived, Japan was in the middle of a prolonged civil war, as competing samurai warlords struggled for domination. Innovations such as muskets and cannons, which might have given an advantage to one side or another, were welcomed. In the first part of the seventeenth century, however, the situation changed drastically. The civil war ended in 1615 with the takeover of the Tokugawa warrior clan, which established itself in the hereditary position of shogun ("generalissimo"), a military dictator ruling in the name of a figurehead emperor. To consolidate their own power

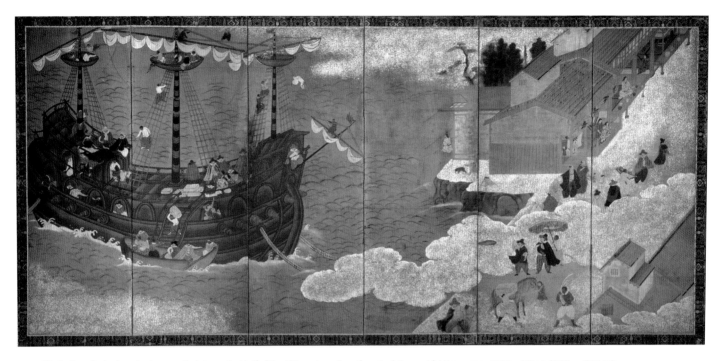

25. *Southern Barbarians at a Japanese Port*. Japan, first half of the 17th century. One of a pair of six-panel folding screens, 154.5 × 346 cm (60¹³⁄₁₆ × 136¼ in.)

and prevent provincial warlords from making independent alliances with the Europeans, the Tokugawas strictly banned Christianity, executing any converts who refused to recant, and cut off most contact between Japan and the outside world.

From the 1630s until the arrival of Commodore Perry in 1853, the only Westerners allowed into Japan were the Dutch, and even they were confined to an island in the harbor of Nagasaki. Traders from China, Korea, and the Ryukyu Islands (now Okinawa Prefecture in Japan) were also admitted, but no Japanese could travel abroad. A few scholars were allowed to visit Nagasaki, learn the Dutch language, and study Western arts and sciences; but for most Japanese, the only contact with the Western world was an occasional encounter with imported luxury goods such as woolen cloth or footed glass goblets.

With no foreign invasions or major internal struggles, Japan during the Edo period was relatively peaceful and

prosperous. The social changes that began to occur during this time were very similar to those that were then occurring in Europe: growing urbanization, the establishment of a cash economy, and, above all, the rise of a middle class. For the first time in Japan, urban merchants and artisans who were not members of the ruling elite but nevertheless had significant disposable income became numerous enough to influence social and cultural developments.

Since participation in government was limited to the hereditary samurai class, and foreign travel was banned for everyone, the newly affluent urban commoners spent their money in the world of popular culture that grew up to accommodate them. The term *Floating World* (*ukiyo*) originally referred to specific entertainment areas in major cities such as Edo, Kyoto, and Osaka; its meaning then expanded to include the world of fashionable pleasures in general. The two

26. *Outside a Kabuki Theater in Sakai-chō* from an untitled series of Customs of the Twelve Months, about 1705–1706. Okumura Masanobu (Japanese, 1686–1764). Woodblock print, 27.2 × 37.8 cm (10¹¹⁄₁₆ × 14⅞ in.)

institutions most strongly associated with the Floating World were the licensed red-light districts, especially the famous Yoshiwara in Edo, and the Kabuki theater, whose colorful, extravagant productions contrasted strongly with the sedate masked Noh theater of the aristocracy (fig. 26). Also part of the urban scene were fashionable clothing and accessories, and stores at which to buy them; restaurants and teashops; sumo wrestling matches; annual festivals that provided frequent excuses for partying and for visits to scenic parks and temple grounds; and constantly changing public displays (with a small entry fee) of everything from miracle-working religious images to imported curiosities to horticulture, to which people of all social classes went to see and be seen.

As the literacy rate of the urban population rose to new heights, the publication of popular works for middle-class commoners became a profitable business. Woodblock printing

had been known in Japan since at least the eighth century but was previously used primarily in a Buddhist context. In the Edo period, printed versions of the classical poetry and fiction that circulated in manuscript among the upper classes were soon supplemented with new stories describing life in the Floating World and illustrated with pictures of fashionable young people in gorgeous modern clothing (and sometimes out of it, since explicit sexual content was not initially illegal). Around 1680 publishers realized that they could sell not only illustrated books but single-sheet printed pictures as well. The new style of art used for prints, book illustrations, and the paintings commissioned from the same artists by more affluent customers was known as ukiyo-e.

For printed books and pictures, the artist's drawing was carved into wooden blocks by professional blockcutters and turned over to professional printers who had mastered the art of

27. *A Bookstore at New Year* from the book *Colors of the Triple Dawn* (*Saishiki mitsu no asa*), 1787. Torii Kiyonaga (Japanese, 1752–1815). Woodblock-printed book, 25.5 × 19.3 cm (10¹/₁₆ × 7⅝ in.)

quickly inking the block, placing the paper facedown on it, rubbing hard with a lightly oiled pad to produce a clear impression, and repeating the whole process rapidly. The publisher controlled the process, hiring artists, blockcutters, and printers, and selling the mass-produced works in bookstores or through street vendors (fig. 27). Although all the major cities had book-publishing industries, the single-sheet pictorial prints were produced mainly in Edo and were considered a special product of the city, often purchased as souvenirs by visitors.

Competition among the publishers led to technical innovations. In the early eighteenth century, black-and-white prints were often embellished with hand-applied color (see fig. 26). Simple color printing, with two or three colors in addition to the black outline, began in the 1740s. Each color was printed from a separate carved wooden block with guide marks at the edges to keep the paper aligned correctly. The breakthrough

to full-color prints, defined as prints with five or more colors in addition to black, came in 1765; the date is known precisely because the earliest mass-produced color prints were pictorial calendars for that year. This method of producing relatively inexpensive color pictures was so satisfactory that it continued to be used until the early twentieth century.

Censorship regulations began to be applied specifically to the printing industry in 1721, as part of a wider program of economic regulation by the shogunate. Explicit erotica, political commentary, and news reporting, whether verbal or visual, were banned. At the same time, however, the restrictions on the importation of foreign books were lifted, and Western books and prints (and Chinese works influenced by Western ones) were allowed into Japan provided they made no mention of Christianity. In the competitive world of ukiyo-e publishing, eye-catching new techniques such as vanishing-point

28. *Archery Contest at the Sanjūsangendō,* about 1759. Maruyama Ōkyo (Japanese, 1733–1795). Woodblock print, 20.9 × 27.2 cm (8¼ × 10¹¹⁄₁₆ in.)

perspective were as welcome as gunpowder artillery had been to the rival warlords of the sixteenth century.

Printed cityscapes of Edo with exaggerated vanishing-point perspective began to be published in the 1740s. In the 1750s the appeal of such pictures was heightened by the introduction of peep-show devices, in a variety of sizes and styles, that used imported Western lenses to enhance the illusion of looking through a small window into a real, separate world.² In Kyoto the young artist Maruyama Ōkyo (1733–1795) was commissioned by a toyshop to make pictures for use in the peep shows that were sold there (fig. 28). Western perspective was seen not as a great scientific and artistic discovery, but rather as an amusing novelty; traditionally prestigious paintings emphasized ink brushwork and clever composition rather than realism. During the second half of the eighteenth century, Ōkyo made himself the leading painter of his day by combining superb traditional brush technique with a new, Westernized sense of three-dimensional space (see fig. 22).

Landscapes and cityscapes remained a minor genre within ukiyo-e until the 1830s, when they suddenly achieved enormous popularity with the two great series *Thirty-six Views of Mount Fuji* by Katsushika Hokusai and *The Fifty-three Stations of the Tōkaidō Road* by Utagawa Hiroshige (see figs. 68 and 11). Both of these series, and their many successors, use a version of Western perspective, although it is approximated by eye rather than worked out through meticulously drawn sight lines. Over the preceding ninety years, this type of perspective had become naturalized in Japan and, although still not universally used, was no longer a novelty. Hokusai's landscapes were the first to be truly appreciated by Westerners, in part owing to the fact that the pictorial space within them was easily comprehensible in Western terms. Without struggling

29. *Plum Estate, Kameido* from the series *One Hundred Famous Views of Edo,* 1857. Utagawa Hiroshige (Japanese, 1797–1858). Woodblock print, 37 × 25.2 cm (14⁹⁄₁₆ × 9¹⁵⁄₁₆ in.)

to understand the space depicted in the prints, Western viewers could concentrate on such features as the skillful line drawing and the way in which the flat areas of color resulting from the printing process were combined to create a three-dimensional effect. Hiroshige's late works in the vertical format were admired both in Japan and, just slightly later, in the West for their unusual viewpoints and framing devices. His

Plum Estate, Kameido of 1857, which combines close-up and distant views of the flowering trees, was copied in oils by Van Gogh (fig. 29).

Early Western collectors of ukiyo-e figure prints highly regarded the works of late eighteenth-century artists such as Torii Kiyonaga and Kitagawa Utamaro, who introduced a new, taller ideal figure typically eight heads in height. This

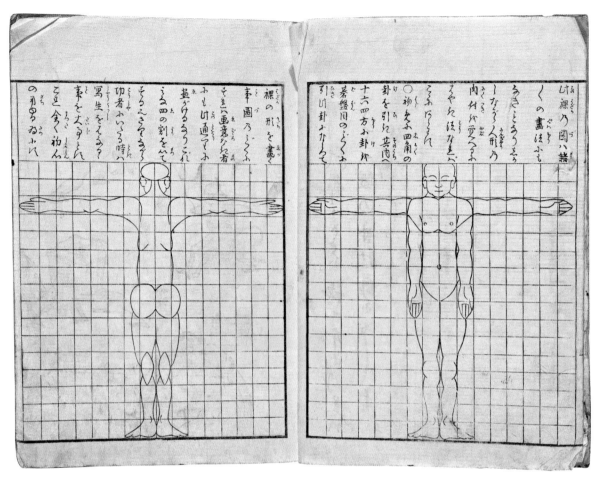

30. *Proportions of a Human Figure* from the book *Abbreviated Sketches of People* (*Jinbutsu Ryakuga shiki*), 1795. Kitao Masayoshi (Japanese, 1764–1824). Woodblock-printed book, 26.4 × 18.8 cm (10⅜ × 7⁷⁄₁₆ in.

elongated figure type is similar to the traditional Western ideal and may in fact have been influenced by illustrations copied from European books (fig. 30).[3] An interest in meticulous observation of the real world, influenced by both Western and Chinese intellectual trends, led Japanese artists to study human anatomy and physiognomy and eventually to produce recognizable likenesses (sometimes deliberately exaggerated into caricature) of celebrities such as Kabuki actors. This interest in precise observation is also reflected in the nature studies that became popular in the 1830s, at the same time as the landscape prints (see fig. 5).

Though ukiyo-e landscapes and nature studies had universal appeal, and there was little danger of misunderstanding their content, Westerners were often confused about the identity and even the gender of human figures. Kabuki actors in female roles, which were required by law to be played by men, might be mistaken for women; and it was often assumed that all or at least most of the women shown in the prints were courtesans of the Yoshiwara. In fact, the beauties seen in the prints represent not only courtesans, identifiable by their multiple hairpins, obi, or sash, tied in the front, and high clogs when outdoors (fig. 31), but also geisha, technically not courtesans but musicians and comediennes who entertained at parties; waitresses at restaurants and teahouses; ordinary middle-class housewives (see fig. 40); and even sheltered daughters of the upper class. The reception of ukiyo-e prints in the West was intertwined with Western fantasies of Japan as a paradise for men.

When Japan reopened to international trade in the 1850s and 1860s, currents of artistic influence flowed in both directions. At the same time that Western artists were encountering Japanese art, Japanese artists were avidly studying Western

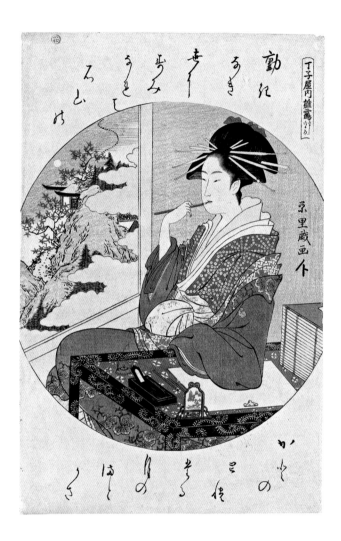

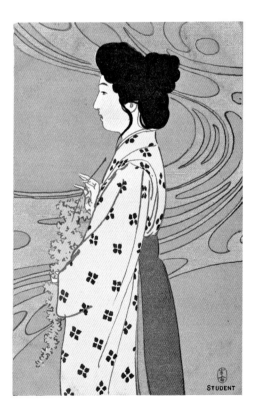

31. *Autumn Moon at Ishiyama Temple: Hinazuru of the Chōjiya* from an untitled series of courtesans for the Eight Views of Ōmi, about 1800. Rekisentei Eiri (Japanese, active about 1781–1818). Woodblock print, 39.5 × 35.1 cm (15⁹⁄₁₆ × 13¹³⁄₁₆ in.)

32. *Student,* about 1900–1910. Kajita Hanko (Japanese, 1870–1917). Published by the Association of Practical Design (Jitsugyō zuan kai). Postcard, 13.8 × 8.8 cm (5⁷⁄₁₆ × 3⁷⁄₁₆ in.)

art. Following the change of government in 1868 known as the Meiji Restoration, Western technologies—including artistic techniques—were taught in Japanese schools, and Japanese citizens were permitted to travel abroad. Art dealers sold Japanese prints in Europe, while aspiring Japanese artists studied under European painters who had themselves been influenced by Japanese art. By the early twentieth century, mutual influences had passed back and forth repeatedly. Newer, international media such as photographs and postcards supplanted woodblock prints as visual expressions of popular culture in Japan and Japanese artists stepped onto the world stage where they became active participants in art movements including Art Nouveau (fig. 32), Art Deco, and Art Moderne.

WOMEN

As Western women assumed more active roles in public life at the turn of the century, they became important participants in a number of fin-de-siècle artistic movements, especially japonisme. They were by turns collectors in the market for exotic goods, artists inspired by the art and culture of the foreign land, and themselves the subjects of numerous works of art. The taste for Japan became associated early on with female consumers who wore imported silks and decorated their homes with curiosities. Japan's culture was imagined to be feminine, symbolized by geishas and courtesans, by Mesdames Chrysanthème and Butterfly. The frequency with which attractive women, or male actors dressed as female beauties, appear in ukiyo-e prints and paintings reinforced this stereotype for some Western observers (fig. 33). Yet others were challenged by the Japanese artists' frank portrayal of the most intimate, everyday activities of their subjects in addition to the more glamorous aspects of their existence. These images offered a variety of new possibilities for the representation of modern women, who were figures of great interest at this time of social change.

Paintings of European beauties dressed in kimono or similar gowns were among the first Japan-inspired works of art in the West, becoming popular during the 1860s and 1870s. *Meditation* (fig. 34), also called *The Japanese Robe*, from about 1872, by the Belgian society painter Alfred Stevens features a young woman dressed in a *kosode* kimono made of light green silk delicately patterned with sprays of white and red blossoms and leaves.[1] The robe is a sign of fashionable good taste; Japanese apparel, silks, and accessories became essential items in chic wardrobes of this period. It also suggests that the sitter is a sensual creature, caught in a dreamy state in the sort of outfit worn to receive intimate visitors, as was the custom of Swann's lover, Odette, in Marcel Proust's novel *Remembrance of Things Past*.

Japanese silk dressing gowns and jackets produced by "native manufacturers" were sold to a Western clientele from the 1860s on, available from firms such as Farmer and Roger's Oriental Warehouse, which became Liberty and Company in London, and the Japanese department store and exporter Takashimaya (fig. 35).[2] The chrysanthemum was a popular decorative motif on such garments, having come to signify Japan abroad in the later nineteenth century, especially after the publication of Pierre Loti's popular novel *Madame Chrysanthème* (1887), one of the sources for Giacomo Puccini's 1904 opera *Madama Butterfly*. These heartbreaking stories of naval officers enticing

33. *Courtesan in the Snow at the New Year,* 1804–1818. Kubo Shunman (Japanese, 1757–1820). Hanging scroll, image: 96.2 × 32.1 cm (37⅞ × 12⅝ in.)

young geishas into becoming their temporary "wives," soon to be deserted upon the return of the officers to the West, appealed greatly to fin-de-siècle audiences.

As *Butterfly* hauntingly demonstrates, Western images of Japan often centered on a stereotypical notion of the Japanese woman. The Orientalist fantasy of sexually available women discovered in faraway lands held considerable sway in the nineteenth century, coloring visions of Japan, as in the 1881 etching *The Prodigal Son: In Foreign Climes* by the French painter and printmaker James Tissot (fig. 36). The costumes and fans collected by the artist at the Parisian curiosity shop La Porte Chinoise might have inspired Tissot's fleet of dancers in a teahouse. He also might have found models in *bijin-ga* prints, a type of ukiyo-e imagery that often depicts inhabitants of the Yoshiwara quarter of Edo, where brothels known as Green Houses catered to male desire. Although wealthy ladies and the wives of merchants frequently appear in these works, and they are sometimes indistinguishable in their finery from the geishas who wore similarly elegant attire, many Westerners seem not to have understood or to have overlooked the possibility that the beauties in these works might be respectable, enthralled as they were by the notion of a land replete with potential mistresses. In Eizan's *Yatsuhashi,* from the series *Fashionable Tales of Ise,* dating from about 1814–1817, for example, the woman represented is probably a fashionable middle-class woman, although no clear symbol of her role appears in the print (fig. 38).

Still, a significant number of artists were less concerned with exoticism than with applying the lessons of Japanese art to the portrayal of modernity and, more specifically, of modern women. Degas found a wealth of creative possibilities in the study of ukiyo-e prints, which he collected.[3] Characteristics of Japanese prints informed his treatment of dancers and bathers, as well as his representation of friends, including his fellow artist Mary Cassatt. In one of his most celebrated etchings, he portrays Cassatt and her sister, Lydia, at the Louvre (fig. 37). His division of the Etruscan gallery into geometric units and his emphasis on the silhouettes and rhythms of the Cassatt sisters' gowns are indebted to the compositional devices of Japanese woodblock prints. So, too, may be his intense focus on the sisters' habits, gestures, and attitudes, although this similarity could be characterized as an affinity, a shared concern for the everyday, the particular, and the unconventional that drove Degas's interest in ukiyo-e.

Cassatt, who collected prints by Utamaro, Hiroshige, Hokusai, and others, was one of the most enthusiastic proponents of Japanese art among her contemporaries. "You *must* see the Japanese," she urged her friend the Impressionist painter Berthe Morisot on the occasion of the landmark exhibition of prints, albums, and illustrated books in 1890 at the Ecole des Beaux-Arts in Paris. "*Come as soon as you can.*"[4] In her painting *Maternal Caress* (about 1902), Cassatt employs the formal devices of Japanese woodblock prints that she first applied to etchings in the early 1890s (figs. 39 and 40). The painting may be compared to an image by the nineteenth-century artist Kikugawa Eizan, or to one of any number of Japanese woodblock prints that intimately portray the bond between mother and child. Cassatt heightens the focus on her subjects by making the couch on which they sit appear to tilt upward, thereby pushing the figures against the picture plane, which is further emphasized by the flat edge of a painting in the upper right corner. The informal pose, a characteristic of Cassatt's work, is reminiscent of Japanese portrayals of women with their children, very often seen embracing, breast-feeding, or bathing, intertwined with more obvious physical affection than had appeared historically in Western art.

Children and mothers or nannies, a habitual presence in well-to-do families, were among the modern-life subjects that caught the attention of other Impressionists and post-Impressionists, including Edouard Vuillard. A boldly rendered nanny and baby are prominent in his drawing for a screen, a decorative project that recalls the screens that were essential features of well-appointed Japanese homes, where they acted as art objects as well as functional elements, used to define the flexible living spaces of traditional architecture (fig. 43). This drawing probably relates to a commission from Paul Desmarais, a member of the wealthy Natanson family, for whom Vuillard made the similarly shaped asymmetric screen *Seamstresses,* in the early 1890s.[5] References to the art of Japan are particularly appropriate for such domestic works, which combine decorative qualities with a focus on the everyday activities of women. In addition to thinking of Japan as a delicate, sensual country, many Westerners glorified it as a place where art flourished in every aspect of existence, including the quotidian, a way of life appealing to Vuillard and his circle.

The languid subject of Emil Orlik's 1899 *English Woman* (fig. 41) gazes into space, an open journal in her lap, in this skillfully designed woodcut. She

recalls the figure in Stevens's painting *Meditation,* but Orlik's treatment of the space—flattened by a low vantage point and animated by geometric shapes and patterns—makes this work more modern and more Japanese in feel. Its sinuous lines are typical of Jugendstil and indicative of Orlik's interest in the work of the French artist Félix Vallotton as well as in the boldly rendered and geometrically rhythmic black-and-white Japanese woodblock prints that had such an influence on Vallotton and Paul Gauguin (fig. 42). A Czech print maker who made his career in Germany, Orlik traveled to Japan in 1900 and stayed there until 1901.

A number of the Western artists who presented such traditionally feminine subjects as families and children in a Japanese style were women themselves. The notable engagement of women artists with Japanese art was due in great part to increased access to education and professors like Arthur Wesley Dow.[6] It also reflects the particular interests and ambitions of individuals, such as Helen Hyde, who found opportunities to develop her career as a professional artist in Japan. Hyde's work was popular and commercial, reinforcing clichés about "Old Japan" and "naughty geishas."[7] Yet during her many years living in Japan, Hyde made a great effort to learn traditional techniques for creating woodblock prints as opposed to the woodcut process used in the West. She studied ink painting with the renowned artist Kano Tomonobu and worked with Emil Orlik in Tokyo, although she later hired Japanese artisans to execute her prints. She had a keen eye for design and her less sentimental works, like the 1915 woodcut *Family Umbrella,* can be refreshingly unpretentious and appealing (fig. 44). —HB

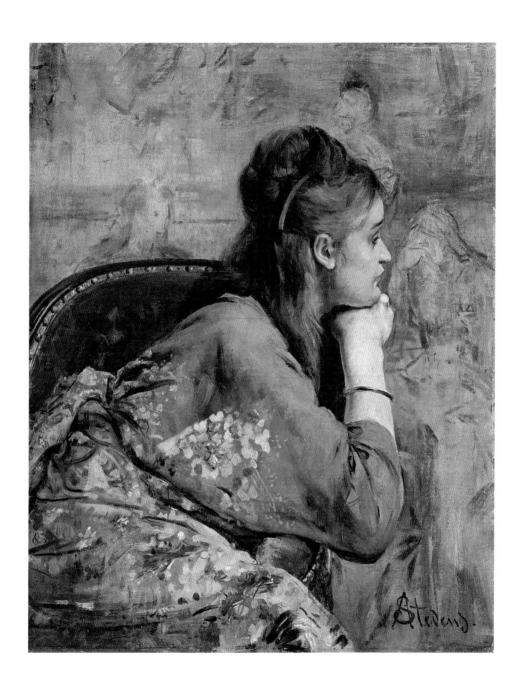

34. *Meditation*, about 1872. Alfred Stevens
(Belgian, worked in France, 1823–1906).
Oil on canvas, 40.7 × 32.4 cm (16 × 12¾ in.)

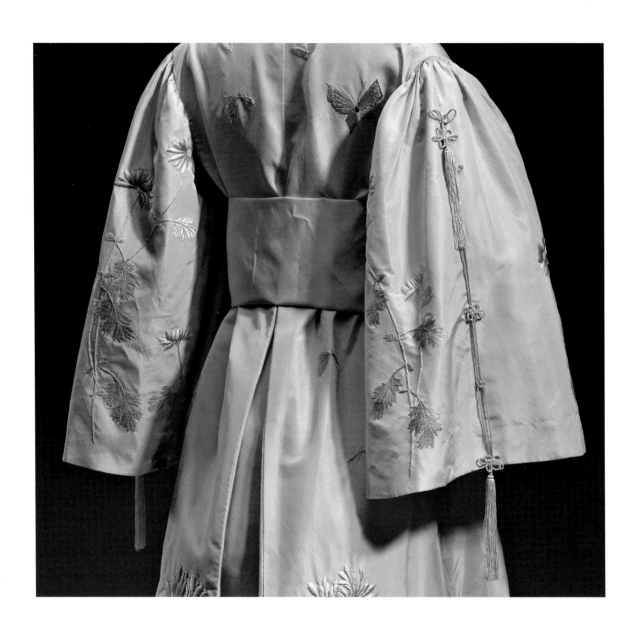

35. Woman's dressing gown. Japan, for the Western market, about 1900. Retailed by Takashimaya. Silk plain weave (taffeta) embroidered with silk, center back length: 141 cm (55½ in.)

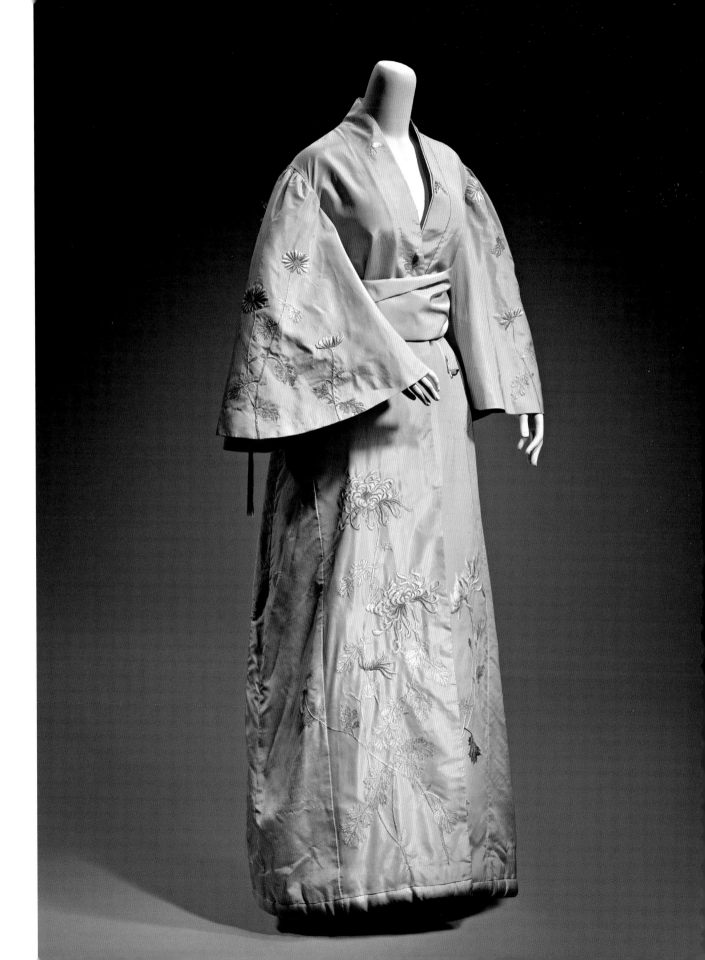

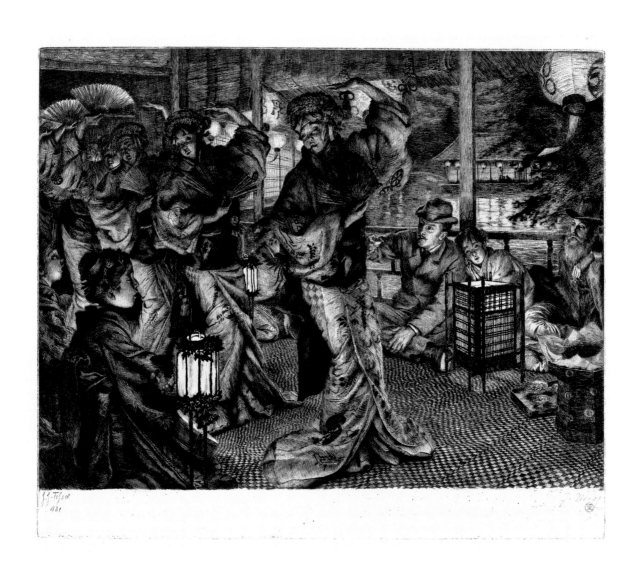

36. *The Prodigal Son: In Foreign Climes,* 1881.
James Jacques Joseph Tissot (French, 1836–1902).
Etching and drypoint, 30.9 × 37.3 cm (12³/₁₆ × 14¹¹/₁₆ in.)

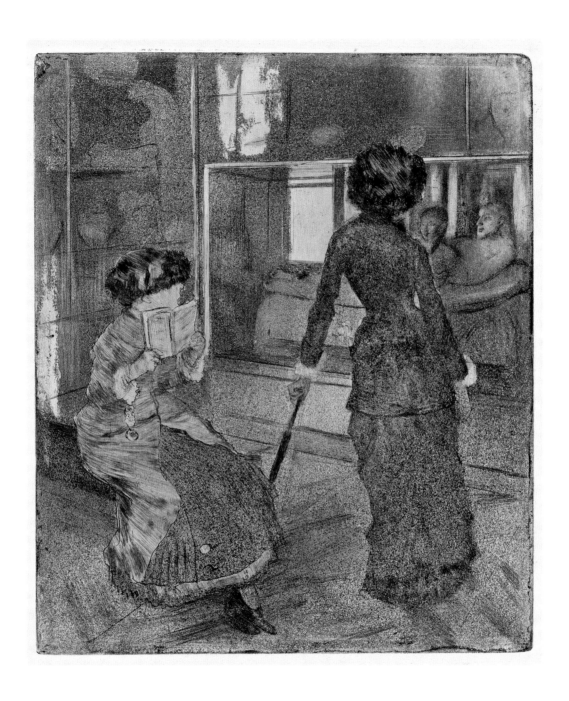

37. *Mary Cassatt at the Louvre: The Etruscan
Gallery,* 1879–1880. Edgar Degas (French, 1834–
1917). Soft-ground etching, drypoint, aquatint,
and etching, 26.7 × 23.2 (10½ × 9⅛ in.)

38. *Yatsuhashi* from the series *Fashionable Tales of Ise,*
about 1814–1817. Kikugawa Eizan (Japanese, 1787–1867).
Woodblock print, 38.3 × 25 cm (15¹⁄₁₆ × 9¹³⁄₁₆ in.)

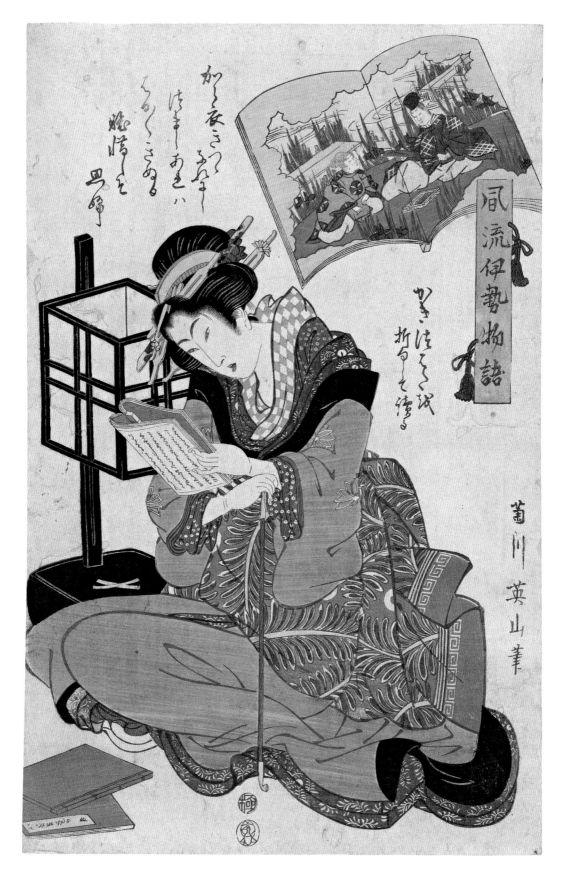

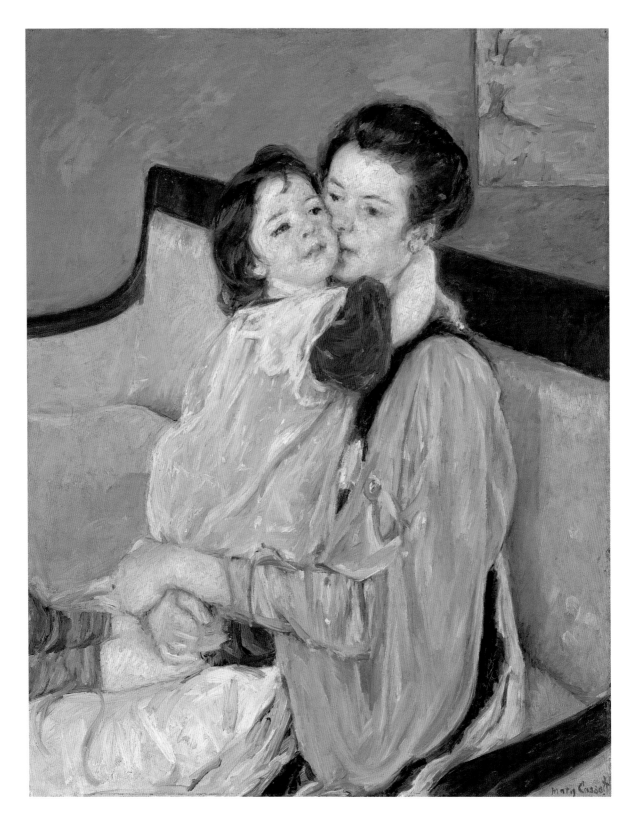

39. *Maternal Caress,* about 1902. Mary Stevenson Cassatt
(American, 1844–1926). Oil on canvas, 92 × 73.3 cm (36¼ × 28⅞ in.)

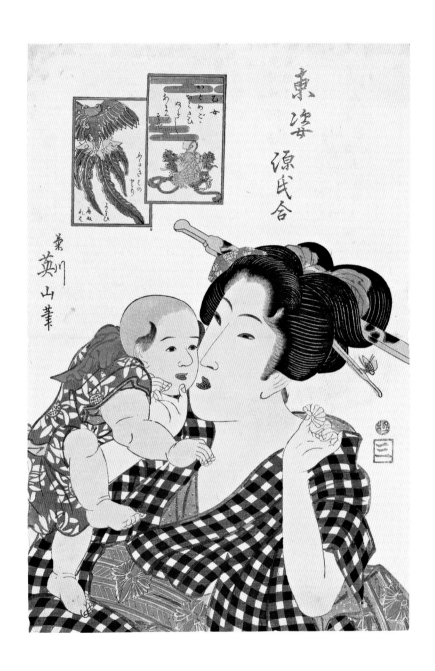

40. *Otome* from the series *Eastern Figures Matched with the Tale of Genji*, about 1818–1823. Kikugawa Eizan (Japanese, 1787–1867). Woodblock print, 37.4 × 25.1 cm (14¾ × 9⅞ in.)

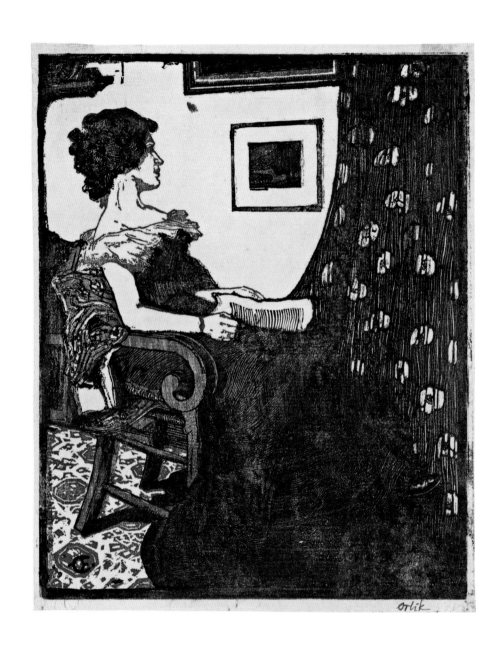

41. *English Woman,* 1899. Emil Orlik (Czech, worked in Germany, 1870–1932). Woodcut, 20.8 × 16.9 cm (8³⁄₁₆ × 6⅝ in.)

42. *Courtesan as Fei Zhangfang* from a series of courtesans imitating
Taoist immortals, about 1706–1708. Okumura Masanobu (Japanese,
1686–1764). Woodblock print, 28.9 × 40 cm (11⅜ × 15¹³⁄₁₆ in.)

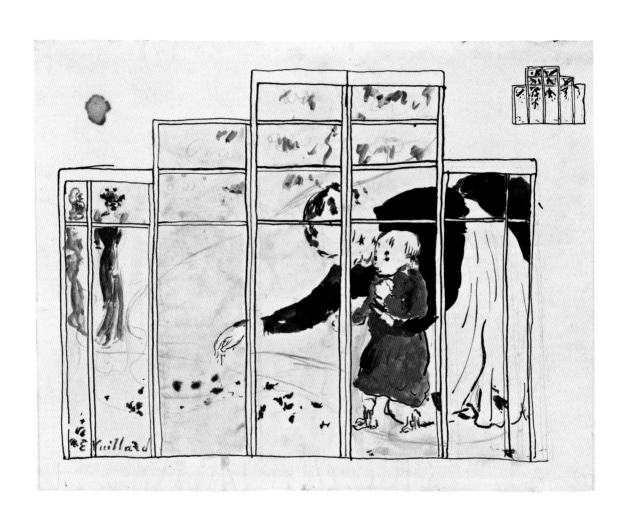

43. *Child and Nurse in the Garden. Project for a Screen.*,
about 1892. Edouard Vuillard (French, 1868–1940).
Drawing, 20 × 30.8 cm (7⅞ × 12⅛ in.)

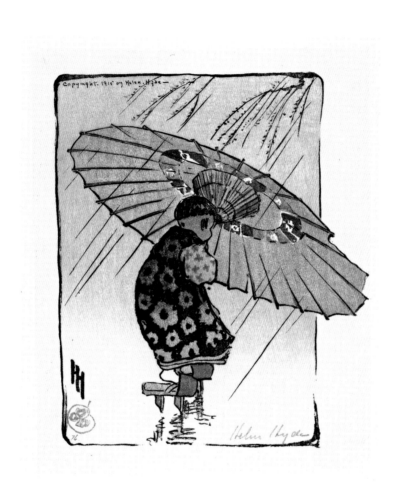

44. *Family Umbrella,* 1915.
Helen Hyde (American, 1868–1919).
Woodcut, 20.5 × 16.7 cm (8¹⁄₁₆ × 6⁹⁄₁₆ in.)

CITY LIFE

Great changes in cities across Europe and the United States set the stage for the cult status that Japanese goods achieved in the late nineteenth century. A distinct urban culture emerged during this period, a result of architectural transformation, the Industrial Revolution, and the merging of public and private spheres. The excitement of this electrifying time captivated a generation of artists who were compelled to move away from tradition toward new subjects and styles that matched the character of modern life. This shift in outlook affected the artistic landscape of many Western cities, including Paris, New York, and London, and laid the groundwork for the eager reception of Japanese art.

European and American artists were fascinated by the major category of ukiyo-e devoted to depictions of city life and its diversions in Japanese prints. Some Western artists welcomed the discovery that the Japanese had engaged seriously with subject matter that many critics dismissed as frivolous or superficial. "These Japanese artists confirm my belief in our vision," wrote the Impressionist Camille Pissarro, after seeing an exhibition of ukiyo-e in 1893.[1] Many took their cues from these works, illustrating and sometimes inventing their own urban scenes, often capturing the pitfalls of modern life as well as its pleasures. In them they found parallels to such pastimes as horseracing, *café-concert* cabarets, and even people watching—all of which had spiked in popularity. The newness of Japanese art to Westerners seemed well matched to the novelty of these activities, as well as to the sensations of immediacy, speed, and theatricality they produced.

Paris was a beacon in this evolving world. Massive renovations during the Second Empire transformed it into a city of boulevards punctuated by cafés, parks, and other entertainments. Some of the most influential French artists of this period were able to capture the curiosities of this way of life, along with its delights. Looking to a page of courtiers preparing for a performance from Hokusai's 1874 book of manga (fig. 45) as a source of unusual gestures and expressions, Henri de Toulouse-Lautrec emphasizes the oddity of a *café-concert* dancer's jerky movements in his lithograph *Caudieux—Petit Casino* of 1893 (fig. 46).[2] In a similarly in-your-face image, Toulouse-Lautrec confronts the viewer with the dynamism of horseracing in *The Jockey* (1899), set in the Longchamp racecourse, identifiable by the windmill in the upper-right corner of the print (fig. 47). Previously a sport reserved for the upper echelons of the aristocracy, horseracing was introduced to a broader

swath of Parisian society with the opening of Longchamp in 1857. The new track became a meeting ground for everyone from the fashionable elite to lowly ragpickers, a fact emphasized by the unusual perspective of Toulouse-Lautrec's image, which places the viewer in the most democratic of positions: standing along the rail, feeling the pounding rush of the race as the horses gallop by. The swooping vantage point, the awkward airborne pose of the horse, and the overall abstraction of Toulouse-Lautrec's figures draw on Japanese stylistic conventions, beautifully illustrated by the 1834 print *Painted Horse Escaping from Ema* by Totoya Hokkei (fig. 48).

With the development of the modern city also came an increased self-consciousness on the part of artists who began to experiment with abstraction and symbolism to a greater degree. This self-awareness was the impetus for the creation of many artists' circles whose goal was to reach a "truer" art. One such circle was the Nabis, a group of disaffected young artists who sought to distance themselves from strict academicism by experimenting with abstraction and color. They created a more interpretive mode of expression under the influence of the artistic giant Paul Gauguin. The intense colorism of Japanese prints was especially interesting to Pierre Bonnard, one of the founding Nabis, who manipulated color to great emotional effect in such works as *The Square at Evening* (fig. 49), part of the twelve-piece lithographic series *Some Scenes of Parisian Life,* created just before the turn of the century. The many artificial hues and the strangely exaggerated hats heighten the frenzied feel of this nocturnal urban scene. Bonnard's interest in times of day, fashionable characters, and the flattened plane may relate to his knowledge of Japanese woodblock prints, although many of their conventions had already become fully enmeshed with avant-garde styles.

City life not only encouraged interest in Japanese art, it also fostered the development of artistic movements that incorporated Japanese elements so thoroughly that they became part and parcel of Modernism. During the mid-1890s, the artist and designer William Nicholson published several woodcut series, many of which depicted ordinary or popular subjects, including animals and the alphabet. His work of this period is characterized by an ongoing interest in silhouetted forms, bold outlines, and uncomplicated shapes. Though there is no evidence that Nicholson had directly based his work on Japanese prints, striking visual connections speak to how much the distinctive style had been incorporated into the modern Western aesthetic. Sporting

events were major social occasions in England during this time, on which Nicholson wittily riffed in *An Almanac of Twelve Sports,* an illustrated calendar for 1898 that was later accompanied by text by Rudyard Kipling. In *Hunting,* the entry for January, a horse rocks back on his haunches in the moment just before launching over a hedge, which the horse in the foreground has just cleared (fig. 50). Nicholson successfully seizes a single fleeting moment through his innovative, asymmetric, and choppy compositions.

In works like Robert Earle Henri's *Sidewalk Café* (fig. 51), from about 1899, it is similarly impossible to untangle the direct influence of Japanese art from that of such artists as Edgar Degas, who had digested the lessons of uki-yo-e in the early years of japonisme. Henri, a leader of the American group The Eight, spent time in Paris early in his career, 1888–1891, and later on, 1898–1900, as both a student and keen urban observer. The Eight, who were also known by the more disparaging moniker the Ashcan School, were recognized for their gritty representations of the unidealized city. Henri had come into contact with Japanese culture at the World's Columbian Exposition in Chicago in 1893, where he visited Japan's pavilion, Phoenix Hall, and was fascinated by the imagery that decorated the space. During this time he hosted the Japanese artist and exposition representative Kubota Beisen, who lectured in Philadelphia on Japanese aesthetics and technique.[3] Much of Henri's work in Paris, including *Sidewalk Café,* illustrated what he saw as the modern urban environment. The asymmetric composition and bursts of bold color against an otherwise dark background in this painting suggest the sway of Japanese prints, as does the large column dividing the picture plane.

Columns were a common convention in Japanese prints, as structural posts were of central significance in teahouses, private homes, and religious spaces in Japan.[4] The symbolic context of this structure is lost in Henri's work, however, where it is transformed for a different purpose, serving to flatten the composition and alienate the figures within from each other. In another work by a member of The Eight, John Sloan, a different device with roots in ukiyo-e artistic conventions—a steeply pitched bird's-eye view— also emphasizes psychological as well as physical distance (fig. 52). Looking down, we see the casual gathering of three disparate urban characters on a city street, which glistens after a rainfall and reflects the pink sky above; this is perhaps based on the view outside Sloan's apartment on Washington Place in New York.

Japanese prints influenced the commercial arts toward the end of the nineteenth century, as their calligraphic patterns, bold shapes, and flattened forms lent themselves to the attention-seeking demands of advertising. Posters designed by artists became popular in the United States in the 1890s, a few years after their popularity spiked in Paris. These hybrid art-advertisements served as precursors to modern marketing.

A poster specially commissioned by the art department of the popular magazine *The Century* encapsulates the ways in which designers adapted Japanese visual techniques to suit their own needs (fig. 53).[5] Here Charles Woodbury presents an evening scene featuring a silhouetted audience shown from behind, through trees and festive dangling lanterns, as fireworks light up the sky. The subject and composition of Woodbury's design echo that of Hiroshige's 1856 *Kinryūzan Temple, Asakusa* (fig. 54), from his popular series *One Hundred Famous Views of Edo,* with its own paper lanterns, prominent columnar structures, and geometric composition.

The cityscape examined through the lens of japonisme offered a solution to artists seeking to interpret and illustrate their modern world. With the vast urban changes, the development of a new culture of leisure, and the introduction of Japanese prints into the art market, a zeal for innovation was nearly unavoidable in cities across Europe and the United States. Even artists like Nicholson, Henri, and Sloan, who weren't explicitly fascinated by Japanese prints, were influenced by their innovative forms and techniques. Perhaps the most resounding legacy of Japanese prints was that their massive popularity inspired not just copyists but widespread and lasting changes in the way art was created.

Japanese visual innovations were not the only modes of representation that traveled around the world after trade restrictions with the West were lifted; popular European and American conventions were also accepted, and even became stylish, in Japan. In Hashimoto Chikanobu's 1884 print *Illustration of the Opening Ceremony of the Union Horse Racing Club's Racetrack around Shinobazu Pond in Ueno Park*, Emperor Meiji celebrates the opening of one of the few Japanese racetracks, built at the suggestion of Ulysses S. Grant during a trip to Japan in 1879 (fig. 55). Though horseracing didn't gain the fierce popularity it enjoyed in Europe, the track's construction speaks to the important exchange between Japan and Western traditions. —JEB

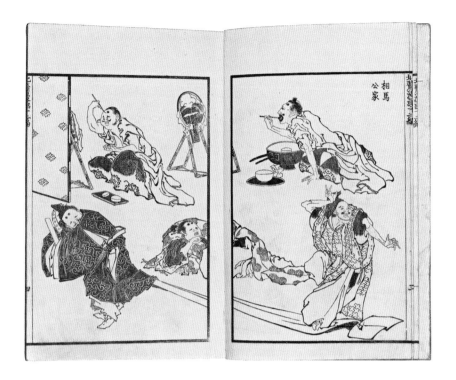

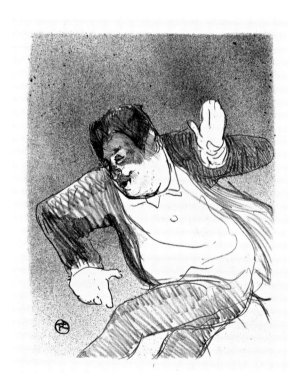

45. *Courtiers Preparing for a Performance* from the book
Hokusai Sketchbooks, Volume Twelve (*Hokusai manga
jūnihen*), 1834. Katsushika Hokusai (Japanese, 1760–1849).
Woodblock-printed book, 22.7 × 15.6 cm (8¹⁵⁄₁₆ × 6⅛ in.)

46. *Caudieux—Petit Casino* from the portfolio
Le Café Concert, 1893. Henri de Toulouse-Lautrec
(French, 1864–1901). Lithograph, 26.9 × 20.8 cm
(10⁹⁄₁₆ × 8³⁄₁₆ in.)

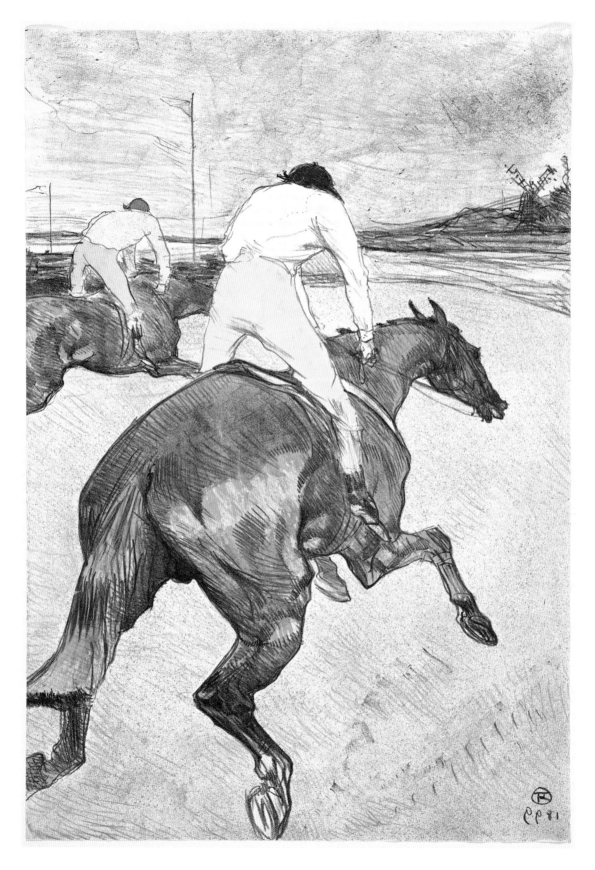

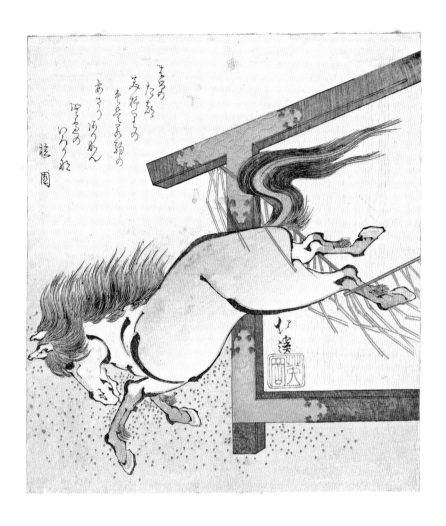

47. *The Jockey,* 1899. Henri de Toulouse-Lautrec (French, 1864–1901). Lithograph, 51.4 × 35.7 cm (20¼ × 14¹⁄₁₆ in.)

48. *Painted Horse Escaping from Ema*, 1834. Totoya Hokkei (Japanese, 1780–1850). Woodblock print, 20.3 × 18.1 cm (8 × 7⅛ in.)

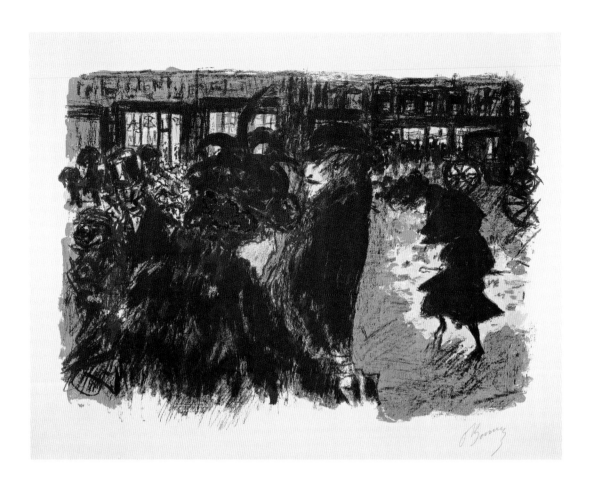

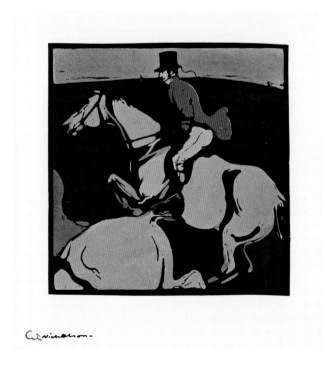

49. *The Square at Evening* from the series
Some Scenes of Parisian Life, about 1897–
1898. Pierre Bonnard (French, 1867–1947).
Lithograph, 27.9 × 38.1 cm (11 × 15 in.)

50. *Hunting* from *An Almanac of Twelve Sports,*
1897. William Nicholson (English, 1872–1949).
Woodcut, 19.9 × 20 cm (7¹³⁄₁₆ × 7⅞ in.)

51. *Sidewalk Café,* about 1899. Robert Earle
Henri (American, 1865–1929). Oil on canvas,
81.6 × 65.7 cm (32⅛ × 25⅞ in.)

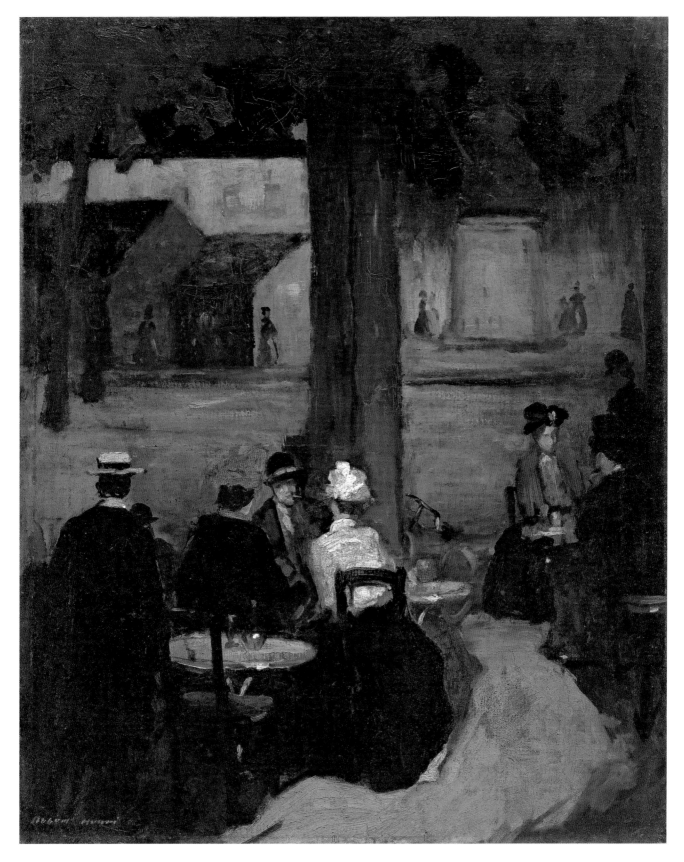

52. *Flowers of Spring,* 1924. John Sloan
(American, 1871–1951). Oil on canvas,
76.5 × 63.8 cm (30⅛ × 25⅛ in.)

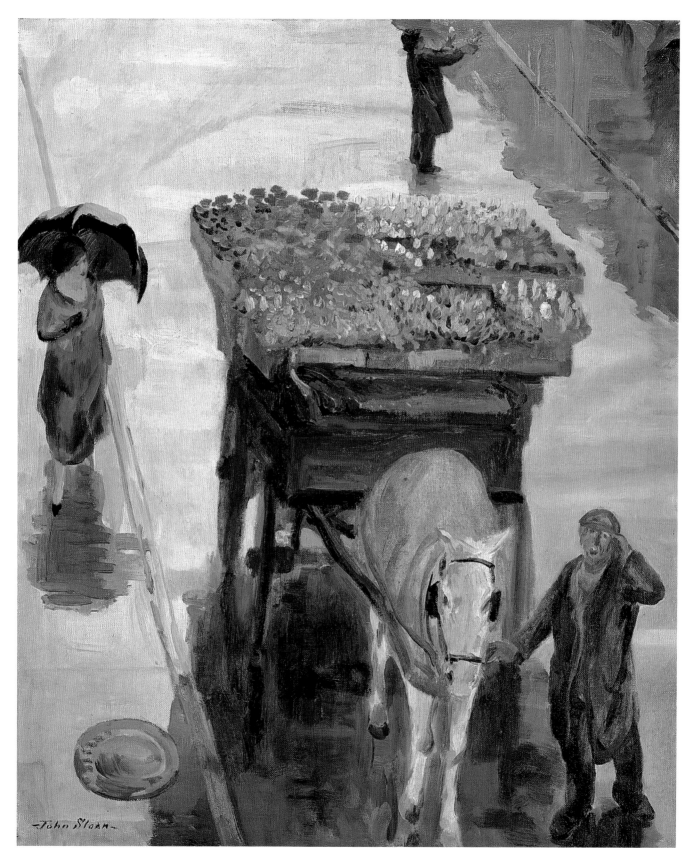

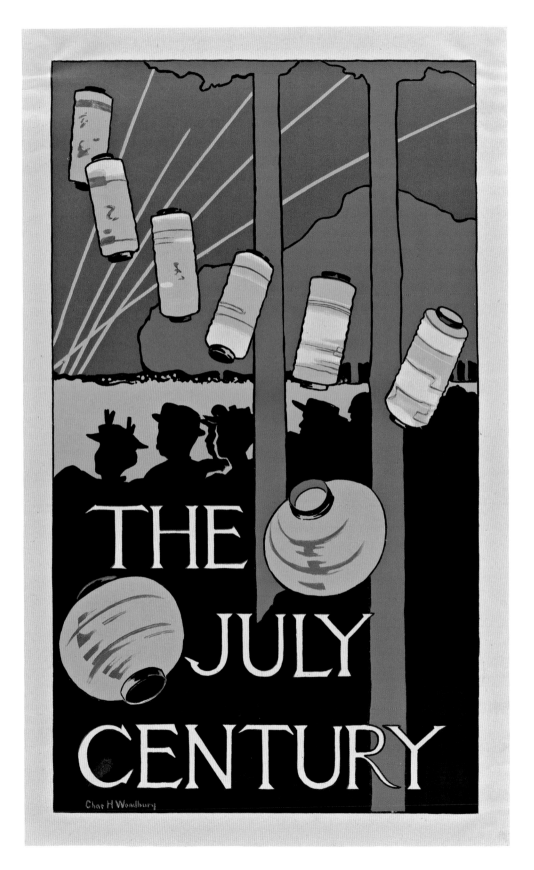

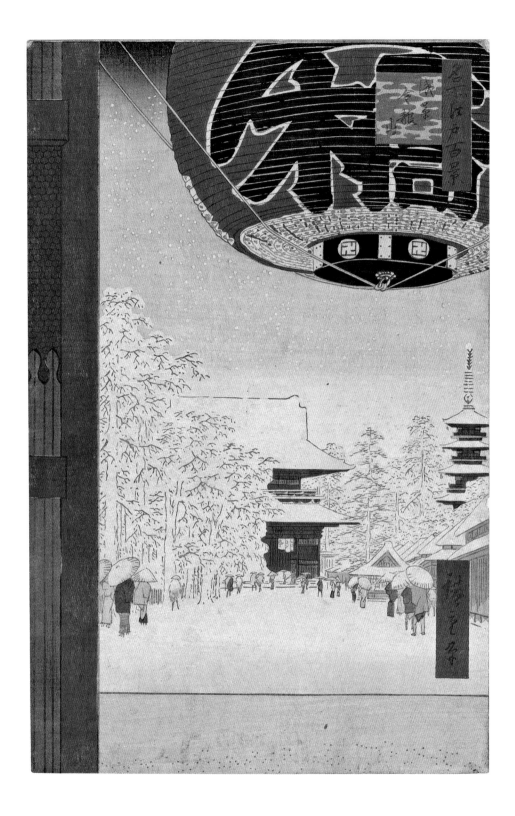

53. *The Century*, July 1895. Charles Herbert Woodbury (American, 1864–1940). Poster, 44.5 × 26.1 cm (17½ × 10¼ in.)

54. *Kinryūzan Temple, Asakusa* from the series *One Hundred Famous Views of Edo,* 1856. Utagawa Hiroshige (Japanese, 1797–1858). Woodblock print, 33.5 × 21.8 cm (13³⁄₁₆ × 8⁹⁄₁₆ in.)

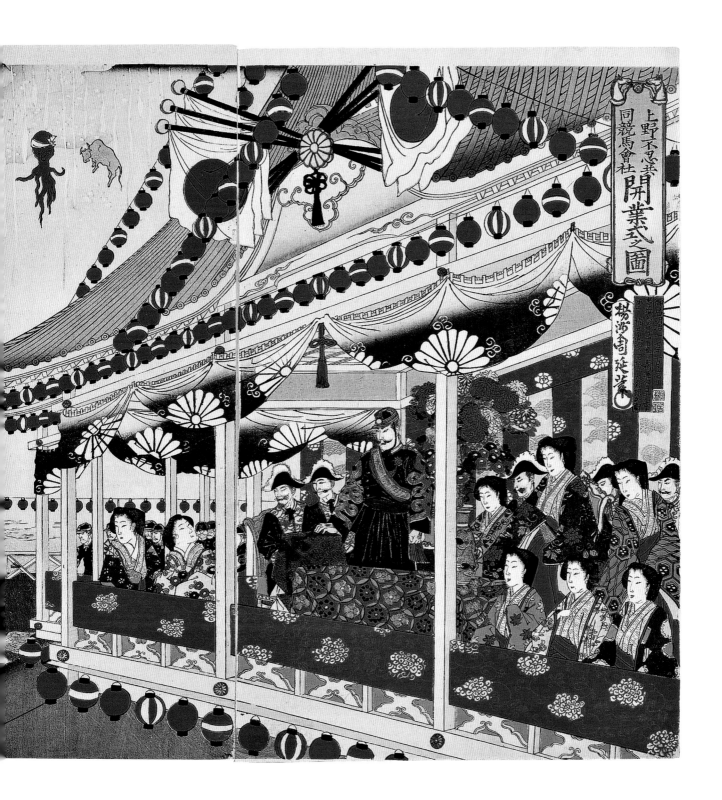

55. *Illustration of the Opening Ceremony of the Union Horse Racing Club's Racetrack around Shinobazu Pond in Ueno Park,* 1884. Hashimoto Chikanobu (Japanese, 1838–1912). Woodblock print, 36.9 × 74.3 cm (14½ × 29¼ in.)

NATURE

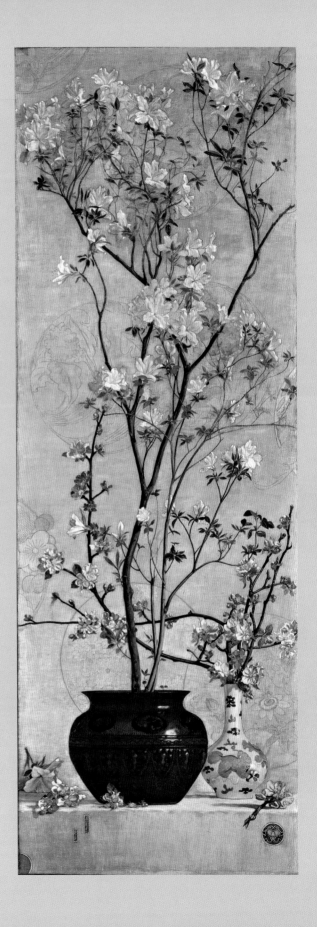

Natural motifs and styles inspired by Japanese art are hallmarks of several major Western artistic movements of the late nineteenth and early twentieth centuries. This is especially true for the decorative arts as well as printmaking, poster design, and photography, all of which previously had been considered minor or commercial in comparison with painting and sculpture, but which drew increasingly serious attention in the fin de siècle. Critics imagined Japanese artists and designers to be universally dedicated to the appreciation of flora and fauna and urged their Western counterparts to similarly devote their efforts. Siegfried Bing wrote in his introduction to the periodical *Le Japon artistique,* which featured numerous paeans to Japanese naturalism over the course of its publication, "The constant guide whose indications he [the Japanese artist] follows is called 'Nature'; she is his sole, his revered teacher, and her precepts form the inexhaustible source of his inspiration."[1] Likewise, his contemporary Lucien Falize believed that "the art of Japan leads us to return to nature," arguing that the revitalization of Western art would surely follow.[2]

A wide variety of organic forms appeared in the Japanese prints, lacquers, silks, bronzes, and ceramics that saturated the Western market in the late nineteenth century. An especially appealing and precious example is the 1789 book *Gifts from the Ebb Tide* by Kitagawa Utamaro, in which closely observed and beautifully rendered shells—exquisitely embossed and printed in ink with mica and brass dust—illustrate light verses (fig. 57). Artists were among the first to purchase such objects: the American painter John La Farge once owned a lacquer box for writing paper with a palmetto design (fig. 58).

The appeal of these imports is evident in the American expatriate Charles Caryl Coleman's *Still Life with Azaleas and Apple Blossoms* (fig. 56) of 1878, which features an assemblage of Japanese objects. His versatile brushwork displays a range of possible representations of flowers, from convincingly realistic sprays to nearly abstract patterns. Composed in the vertical format of a Japanese scroll or the panel of a screen, it was intended to be part of the decorative scheme of a room in a private home. The Aesthetic movement of the 1870s and 1880s, which heralded an art-for-art's-sake philosophy, valued the integration of the fine and decorative arts in skillfully designed interiors, which was believed to characterize Japanese domestic life.

In a similar spirit, the British silver manufacturer Elkington and Company borrowed motifs and patterns from Japanese art, akin to those found

56. *Still Life with Azaleas and Apple Blossoms,* 1878. Charles Caryl Coleman (American, 1840–1928). Oil on canvas, 180.3 × 62.9 cm (71 × 24.7 in.)

in *Butterfly and Peonies* (about 1830) by Katsukawa Shunkō II, to lend an exotic flavor to an otherwise typically Western Victorian tea set (figs. 59 and 60) in 1874–1875. Of course, tea drinking had long been associated with Japan and China, but by about 1875, when this tea set was manufactured, the practice had also been well established in the West, becoming a quintessentially British tradition with an expected group of accoutrements. The butterflies, flowers, bamboo shoots, and floral medallions provide delightfully idiosyncratic surface ornamentation and grant a natural sensibility to what is actually a fine example of cutting-edge technology in the decorative arts. The set was created with an industrial technique called electroplating that had been patented by the firm's founder, Frederick Elkington. Though this tea set is largely machine-made, its fine imagery and workmanship still manage to cater to the taste for handcrafted, unique objects that also fed the period's mania for all things Japanese.

England was a center for design reform, which encouraged the study of non-Western art for the rejuvenation of the decorative arts. Rutherford Alcock's magnificent Japanese collections on view at the London International Exhibition of 1862 were one initial spark for this movement. The travels and writings of Christopher Dresser served as another. Dresser visited Japan in 1876, collecting objects for study as well as researching his book *Japan: Its Architecture, Art and Art Manufactures* (1882). A planter manufactured by Minton and Company about 1883 teems with references to nature and the East (fig. 61). It was almost certainly designed by Dresser, who placed botany in his pantheon of stimuli for the improvement of ornament. The planter marks a high point in the application of such motifs to the surface of objects, a tendency that in time would be abandoned by many artists and designers, including Dresser, who would later eschew most ornament in favor of simple forms, many of which were derived from the most elemental Japanese shapes.

The impulse to rejuvenate was equally strong in Europe and the United States, evident in such movements as international Art Nouveau. Though Art Nouveau derived its stylized organic forms in part from Japanese art, its philosophy, which encouraged the highest levels of creativity in all aspects of media, also found parallels in Japanese culture. The poster craze of the 1890s greatly benefited from this shared belief in the merits of the so-called minor arts, at first in France and then in the United States.

William Bradley's 1896 poster promoting his self-published periodical *Bradley: His Book* is a masterpiece of graphic design and a remarkable example of American Art Nouveau (fig. 62). The elongated flowing gown of the maiden and the rhythmically arranged feathers of the peacock she kisses evoke the Japanese woodblock prints available to Bradley in Boston, but they also speak to Bradley's knowledge of other branches of contemporary art, including the Pre-Raphaelites and the Symbolists. A host of possible sources and influences have been united here into a cohesive style, in which a variety of motifs are subsumed within a greater whole.

Style, composition, and structure became increasingly important concepts to artists in this period, as they moved away from realism toward new ways of interpreting the world around them. Arthur Wesley Dow encouraged his students to study nature but not to imitate it. He emphasized the artistry alive in any subject, the "visual music" that the Japanese were able to capture "with but a hint of facts."[3] His *Lotus*, from about 1900, is an exercise in restraint and suggestion (fig. 63). It captures the geometry of the flower, as well as its simple poetry—the lotus as a spiritual symbol was meaningful on many levels to the Buddhists he knew in Boston. The intense blue of Dow's cyanotypes, similar to that of Bradley's peacock, brings to mind the Prussian blues used by so many Japanese ukiyo-e artists; it was, interestingly, a color they had adopted from Westerners.

Dow's fellow American Margaret Patterson shared his interest in the abstract principles of natural beauty. An appreciator of Japanese woodblock prints, she adopted woodcut as her preferred medium. The bright colors, broad shapes, and concentrated views of her floral still lifes share the intensity of certain Japanese designs (figs. 64 and 65). The lack of sentimentality in her images, as well as the careful design and unmediated vibrancy seen in pieces such as *Summer Flowers*, from the 1920s, are strikingly modern.

Although japonisme generally moved away from exoticism in the twentieth century, there were important exceptions to this rule.[4] In the 1923 painting *Still Life with Sea Shells*, for example, the eccentric Belgian artist James Ensor assembled a Japanese fan, teacup, and saucer along with rare shells as a group of curiosities—the sort of things one might have found in his parents' coastal tourist shop (fig. 66). Displayed beneath the lightly sketched figure of a nude in the upper-right corner, the objects recall the northern tradition of symbolically laden still lifes and the eighteenth-century taste for chinoiserie,

as well as the newly emerged Surrealist habit of searching through flea markets and antique stores for compelling oddities, often with psychosexual overtones. The Japanese objects, like the shells, add a kind of spice—foreign, lushly feminine, and collectible—to Ensor's evocative ensemble.

Frederick Carder's glass *Blue Aurene* fan vase from about 1927, on the other hand, moves toward the clean lines of high Modernism (fig. 67). Its iridescent sheen and fanlike shape bear testament to Carder's roots in the Aesthetic movement, but the vase leaves behind the quotations and references that characterized early japonisme and instead adopts a sensibility informed by years of cultural exchange and ever-increasing affinity. It favors an uncomplicated structure, limited surface embellishment, beautiful materials, and simplified abstract forms—an appreciation of nature at its most elemental (water, air, sky, clouds)—qualities valued in the art of Japan by Dow, Frank Lloyd Wright, and other pioneers of modern design. —HB

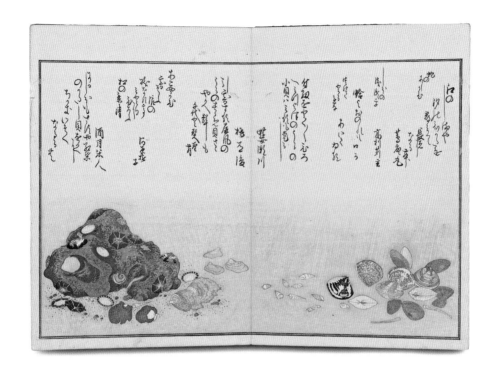

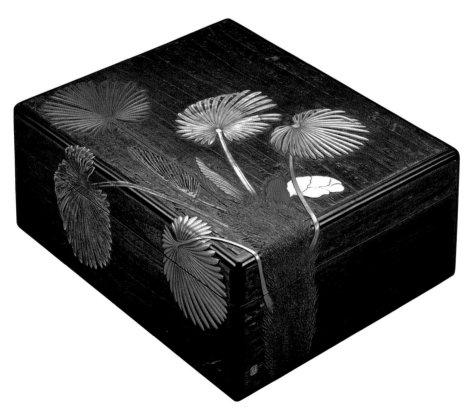

57. *Shells* from the book *Gifts from the Ebb Tide* (*Shiohi no tsuto*), 1789. Kitagawa Utamaro (Japanese, died in 1806). Woodblock-printed book, 27.2 × 19.1 cm (10¹¹⁄₁₆ × 7½ in.)

58. Box with palmetto design for writing paper, 17th to 18th century. Attributed to Ogawa Haritsu (Japanese, 1663–1747). Paulownia with lacquer and inlaid decoration, 11.2 × 23.8 × 28.5 cm (4⅜ × 9⅜ × 11¼ in.)

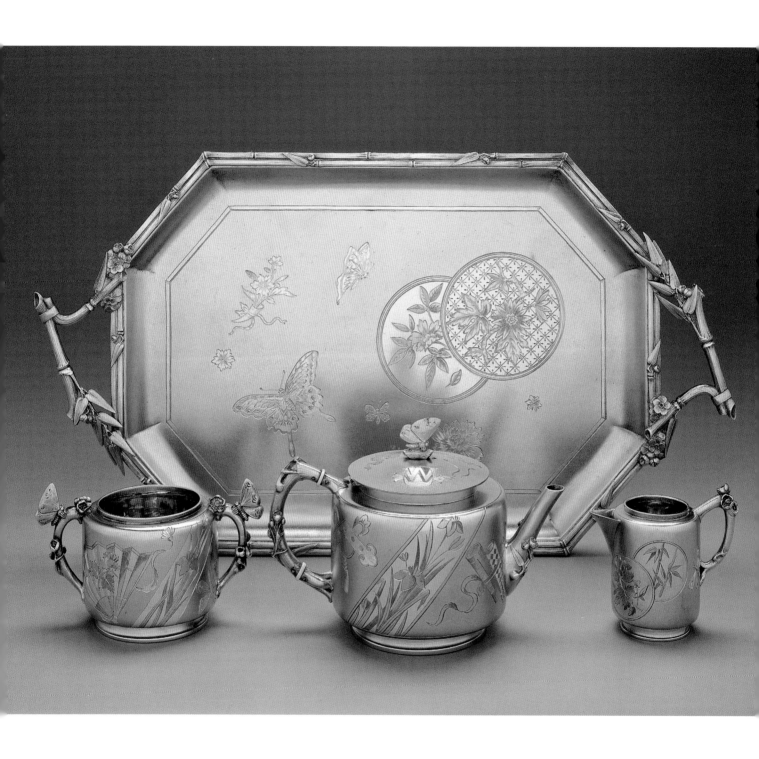

59. Tea set, 1874–1875. Manufactured by Elkington and Company, Birmingham, England. Silver, gilded silver, baleen, Teapot: 11.8 × 16.7 cm (4⅝ × 6⅝ in.)

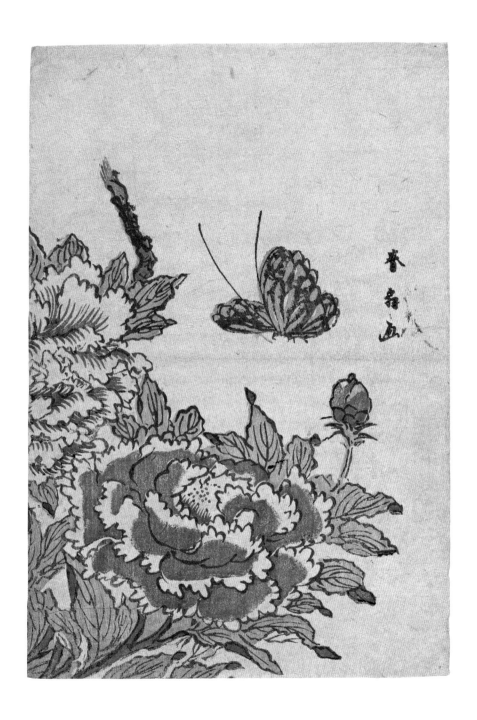

60. *Butterfly and Peonies,* about 1830.
Katsukawa Shunkō II (Japanese, 1762–about 1830).
Woodblock print, 22.2 × 15.5 cm (8¾ × 6⅛ in.)

61. Jardinière, about 1883. Manufactured by Minton and Company, England. Probably after a model by Christopher Dresser (English, 1834–1904). Glazed earthenware, 45.7 × 53.3 × 44.5 cm (18 × 21 × 17½ in.)

62. *Bradley: His Book*, 1896. William H. Bradley (American, 1868–1962). Woodcut and lithograph, 106.2 × 74 cm (41¹³⁄₁₆ × 29⅛ in.)

63. *Lotus,* about 1900. Arthur Wesley Dow
(American, 1857–1922). Photograph,
20.3 × 12.7 cm (8 × 5 in.)

Lotus

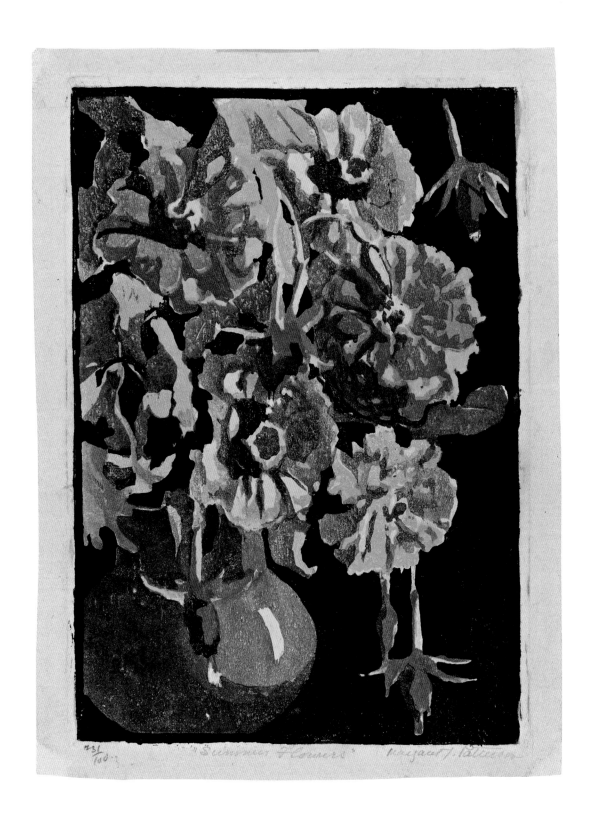

64. *Summer Flowers*, 1920s. Margaret Jordan Patterson (American, born in Java, 1867–1950). Woodcut, 25.5 × 17.8 cm (10 1/16 × 7 in.)

65. *Design of Peonies and Chrysanthemums.* Japan, 1866. Woodblock print, 38 × 25.7 cm (14 15/16 × 10 1/8 in.)

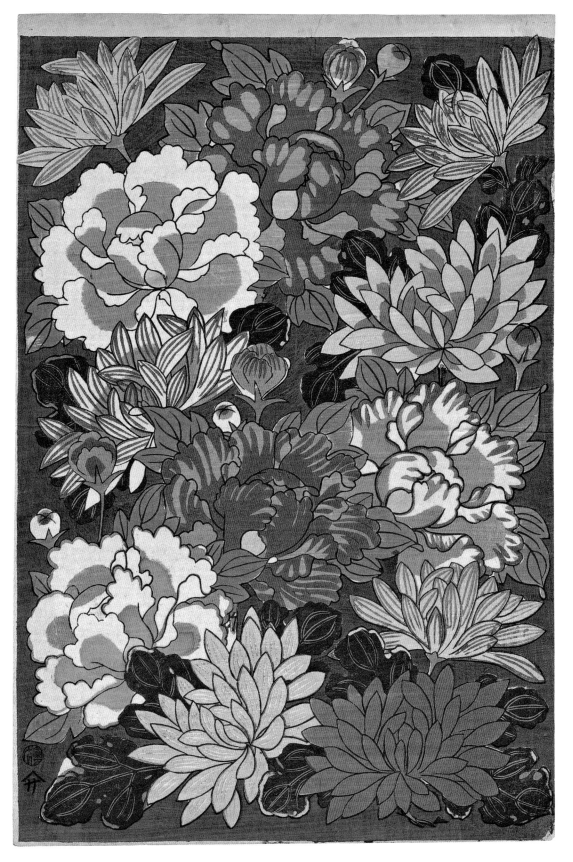

66. *Still Life with Sea Shells,* 1923.
James Ensor (Belgian, 1860–1949). Oil on
paperboard, 44.5 × 55 cm (17½ × 21⅝ in.)

67. *Blue Aurene* fan vase, about 1927. Designed by Frederick C.
Carder (American, born in England, 1863–1963). Manufactured
by the Steuben Division of Corning Glass Works, Corning, NY.
Iridized lead glass with applied ornament, 21.6 × 17.8 × 10.2 cm
(8½ × 7 × 4 in.)

LANDSCAPE

Japanese approaches to color, perspective, and light in the depiction of landscapes offered compelling aesthetic possibilities to Westerners already enamored of the country's sensitivity to nature and its ever-changing beauty. Artists and critics remarked that the bright colors of ukiyo-e prints made them feel as though veils had been lifted from their eyes. Unlike European painters, who tended to use shadows to create convincing three-dimensional forms, "the Japanese did not see nature swathed in mourning . . . it appeared to them as coloured and full of light."[1] Their vistas, moreover, gave the impression of distance without relying exclusively on perspective, the favored method of Western landscapists. Instead, the Japanese employed contrasts in color, the repetition of forms, and the power of suggestion—"one wave stands for the whole sea"—to animate views of Mount Fuji or important sites in Edo.[2] In Hokusai's *Hodogaya on the Tōkaidō*, for example, the artist creates a rhythmic interplay of repetition and variation with a row of lively trees. These trees define the foreground and lend it a sense of dynamism, echoing the passage of the figures below, while also suggesting the continuation of the road beyond the confines of the picture plane (fig. 69). The print, of about 1830, is from *Thirty-six Views of Mount Fuji*, the first major landscape series, in which Hokusai explores a famous landmark with great attention to variations of season, time of day, and light.

John La Farge, one of the first American artists to study and collect Japanese art, was highly attuned to the colors of ukiyo-e prints, which he probably discovered in Paris in the late 1850s, around the time that he became interested in the theories of the nineteenth-century chemist Michel-Eugène Chevreul, who was among the first to develop a systematic study of the psychological effect of color. La Farge's emphasis on the atmospheric effects of a cloudy sky in *A Hillside Study (Two Trees)* of about 1862 anticipates the broad and sensual tonalities of his later paintings and designs for stained glass, which are clearly indebted to the lessons of Japanese art (fig. 68). This sky would not, however, signal a particular allegiance to japonisme were it not for the overall design of the painting. Slimly vertical and anchored by impressively tall trees stretching beyond the borders of the canvas, the painting has more in common with Japanese prints and hanging scroll paintings than with other Western landscapes dating to the early 1860s.

Repeated trees, trellises, and gridlike structures are familiar motifs in Japanese art that quickly became part of the modern Western repertoire,

68. *A Hillside Study* (*Two Trees*), about 1862. John La Farge (American, 1835–1910). Oil on canvas, 61 × 32.7 cm (24 × 12⅞ in.)

a development that arguably contributed to the prominence of the grid in twentieth-century abstraction. Vertical and horizontal structures offered a way of organizing landscape that was legible while also decorative or symbolic, "creating interplay between picture surface and pictorial space," in the words of the Czech artist Emil Orlik.[3] *Pine Forest* (*Tannenwald*), a rare early woodcut on Asian paper made in the mid-1890s by the groundbreaking designer Peter Behrens, takes advantage of this relationship (fig. 70). Rhythmically arranged trees hover on the surface in the foreground before receding into an infinite primeval woodland, combining the Romanticism of Behrens' German artistic antecedents with the geometric sensibility of his Jugendstil present.

The trees in Edvard Munch's 1893 *Summer Night's Dream* (*The Voice*) demarcate an alternative realm, the emotional sphere of sexual awakening, here embodied by a young, ghostly woman in a forbidding park (fig. 71). Though Munch may have derived the motif of tall, vertically aligned trees from Japanese art on view in Paris, it is equally likely that he borrowed it from avant-garde artists who had already incorporated such lessons into their work. His trees encroach on the maiden, designating the area surrounding her as abstract, otherworldly, and masculine, with a symbolic potency that evokes the work of Paul Gauguin. Gauguin frequently indicated spiritual spaces through the use of elements that divide the composition into discrete sections. These were often trees and other shapes borrowed from ukiyo-e prints, medieval stained-glass or cloisonné, and a host of other traditions he termed "primitive." In his 1889 painting *Landscape with Two Breton Women,* a low-lying branch cloisters figures resting and eating, who appear to be lost in thought or prayer (fig. 72). Gauguin believed that Breton women were living embodiments of a precivilized world close to its spiritual roots, and he developed a painting style that synthesized elements of non-Western, historic, and folk art while living in their midst.

The Montmartre artist Henri Rivière also found a wealth of appealing subjects in Brittany's rural agriculture and rocky coastline. His commitment to japonisme was among the strongest of his generation; his remarkable collection of Japanese art is now housed in the French national library. Rivière often worked in series, displaying a special appreciation for Hokusai's *Thirty-six Views of Mount Fuji* in his views of Paris and the surrounding countryside. His debt to the Japanese master is particularly clear in his *Working in the*

Fields, part of a group of four lithographs of Brittany from 1906 titled *From the Northwestern Wind,* and in his use of ephemeral features like clouds and smoke to clearly divide the picture plane into sections (fig. 73).

Atmospheric effects were handled very differently by James McNeill Whistler, whose attention was drawn to the shifting, nebulous character of haze, light, shadow, water, and steam. In his more experimental etchings, Whistler took advantage of the medium's ability to express the most ephemeral variations of light and shadow, drawing an image on a copper plate and then manipulating the plate during the printing process to suggest different times of day and season.

Whistler's *Nocturne: Palaces,* depicting two Venetian palaces connected by a bridge over a canal, is asymmetrical and relatively flat, signs of Japanese influence (fig. 74). But this is a japonisme far removed from the clear references to porcelain and kimono in his paintings of the 1860s, or his statement that "the story of the beautiful is already complete . . . broidered, with the birds, upon the fan of Hokusai—at the foot of Fusi-yama" in the last lines of a celebrated lecture in which he defended his artistic principles.[4] The 1879–1880 print represents instead a less obvious, if no less important, development: the adoption of a concern for the features of the landscape and the most nuanced ways of portraying them, a point of view many Westerners felt was among the most inspiring aspects of Japanese art.

Claude Monet held in great esteem the ability to create a profound effect with subtle indications of setting and atmosphere. In conversation with a critic in 1909, he stated: "If you insist on forcing me into an affiliation with anyone else . . . then compare me with the old Japanese masters; their exquisite taste has always delighted me, and I like the suggestive quality of their aesthetic, which evokes presence by a shadow and the whole by the part."[5] Like Whistler, he found water juxtaposed with a building, bridge, or vegetation—a subject familiar from Japanese art (fig. 75)—especially appealing for explorations of a "suggestive" aesthetic. Monet's garden and its water-lily pond with a Japanese footbridge became his focus in later years, as he produced a series of paintings that are as close to Zen-like meditations on nature and man as any in the history of Western art (fig. 76).

Frank Morley Fletcher also applied the lessons of Japanese art to watery vistas in his native Britain, working mostly in woodcut. *Flood Gates* (fig. 79) is an interpretation of an English landscape, with figures standing on a bridge

formed by the floodgates that control the flow between two bodies of water. The 1899 work is rendered in bands of colors that achieve the effect of the modulated tones (*bokashi*) produced by Japanese woodblock printers working with different concentrations of ink on a carved woodblock. Fletcher's book *Wood-block Printing: A Description of the Craft of Woodcutting and Colourprinting Based on the Japanese Practice* (1916) moved a generation of artists in England and California, where he taught at the Santa Barbara School of Art, to master the technique.

Like woodblock printing, photography attracted significant artistic attention in the early twentieth century. For the Pictorialists, the Japanese proved the value of an "aesthetic of simplicity, abstraction, evocative empty spaces, even narrow vertical formats."[6] Karl Struss, one of the more important members of this circle, captured these qualities in a photograph from 1909 of the East River in New York City (fig. 77). The composition's rhythmic zigzag through piers and ferryboats is informed by such prints as Hiroshige's *Pine of Success and Oumayagashi, Asakusa River* (fig. 78). Interested in ukiyo-e and the Western art that it had already influenced, many Pictorialists focused serious attention on such insubstantial things as reflections in water or patterns in sand. This was a small but telling sign of the shift in priorities that occurred in advanced Western art during the late nineteenth and early twentieth centuries, a shift precipitated by the introduction of the Japanese tradition, which granted air and light the same importance as people and buildings in pictorial space.

Despite a growing appreciation for Japanese art in the West, young artists in turn-of-the-century Meiji-era Japan were less likely to receive instruction in their own heritage than to be taught Western techniques. Educated in oil and watercolor painting, Yoshida Hiroshi began his career by specializing in applying these Western methods to the depiction of traditional Japanese subjects. The combination was highly appealing to the many Americans who acquired work by Yoshida during his first voyage to the United States—a journey he undertook on the advice of the great collector Charles Lang Freer—as well as to reporters, curators, and museum directors in Detroit, Boston, and beyond.[7] On his third and final visit to the States, however, Yoshida began work on a very different series, drawing sketches of American landmarks for color woodcuts he later executed in Japan. One print from 1925 presents the

enormous rock face El Capitan in Yosemite, an iconic American natural monument (fig. 80). Yoshida's composition is somewhat Western in feel, as there is the suggestion of a straightforward recession into space through the valley leading to the enormous rock face; but the use of pure colors and the lack of sculptural modeling, in addition to the inclusion of Japanese characters and symbols, lend the print an equally Eastern sensibility. Dedicated to famous landscapes, the entire series is a beautiful example of cross-pollination, engaging Japanese and Western styles in equal measure. —HB

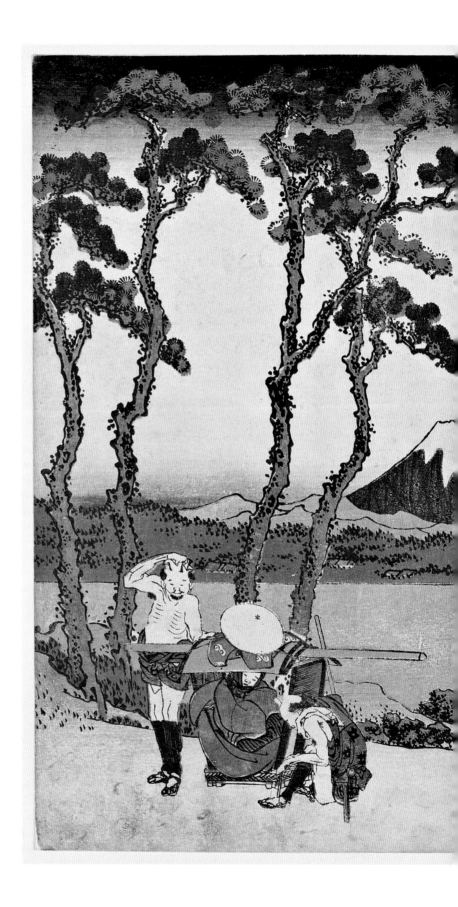

69. *Hodogaya on the Tōkaidō* from the series *Thirty-six Views of Mount Fuji*, about 1830–1831. Katsushika Hokusai (Japanese, 1760–1849). Woodblock print, 25.5 × 36.8 cm (10¹⁄₁₆ × 14½ in.)

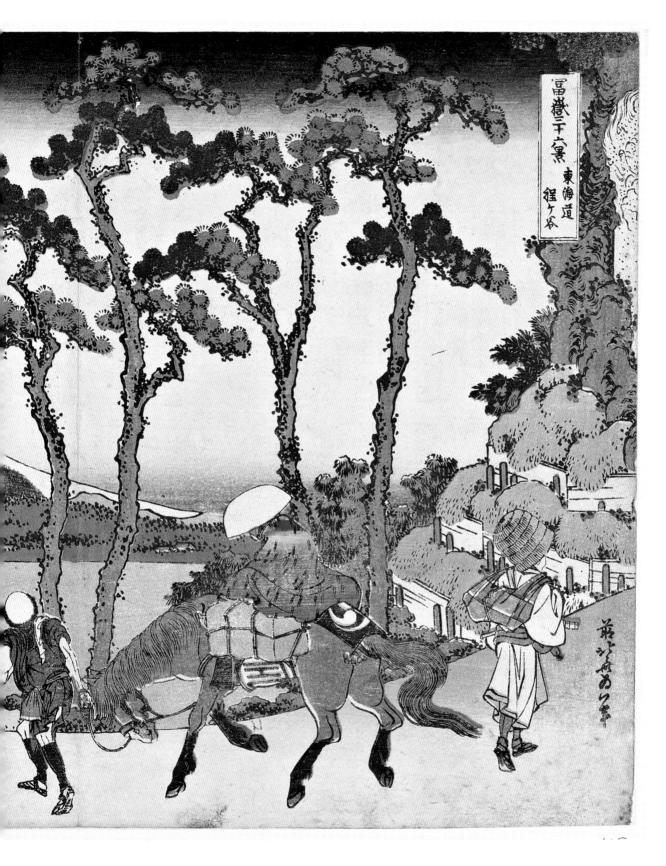

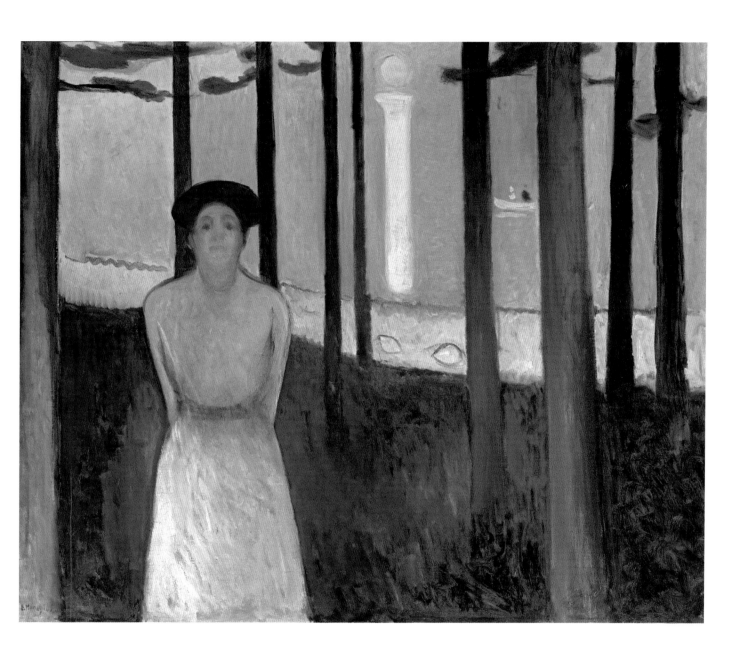

70. *Pine Forest* (*Tannenwald*), mid-1890s.
Peter Behrens (German, 1868–1940). Woodcut,
27 × 15.2 cm (10⅝ × 6 in.)

71. *Summer Night's Dream* (*The Voice*), 1893.
Edvard Munch (Norwegian, 1863–1944). Oil on
canvas, 87.9 × 108 cm (34⅝ × 42½ in.)

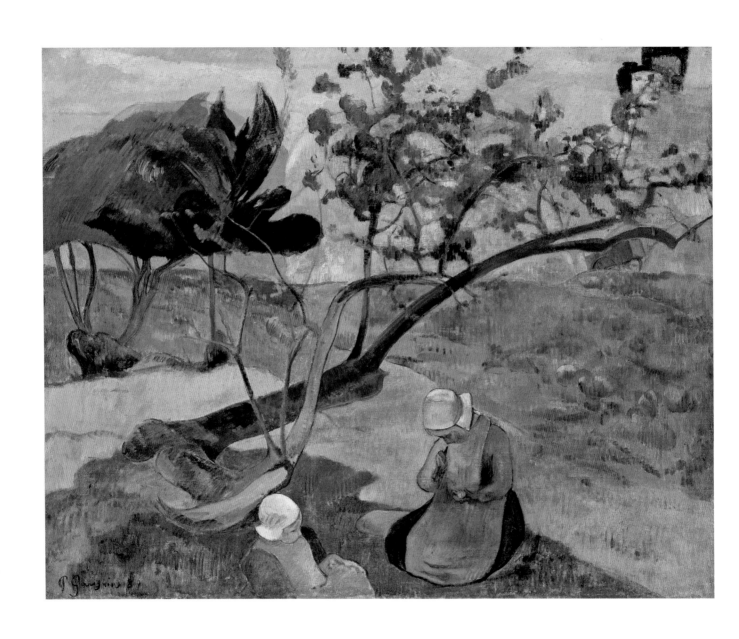

72. *Landscape with Two Breton Women*, 1889.
Paul Gauguin (French, 1848–1903). Oil on canvas,
72.4 × 91.4 cm (28½ × 36 in.)

73. *Working in the Fields,* 1906.
Henri Rivière (French, 1864–1951).
Lithograph, 37.7 × 50 cm (14¹³⁄₁₆ × 19¹¹⁄₁₆ in.)

74. *Nocturne: Palaces* from the group *Second Venice Set,* 1879–1880.
James Abbott McNeill Whistler (American, worked in England,
1834–1903). Etching and drypoint, 29.5 × 20 cm (11⅝ × 7⅞ in.)

75. *Bamboo Yards, Kyōbashi Bridge* from the series *One Hundred
Famous Views of Edo,* 1857. Utagawa Hiroshige (Japanese, 1797–1858).
Woodblock print, 37 × 25.2 cm (14⁹⁄₁₆ × 9¹⁵⁄₁₆ in.)

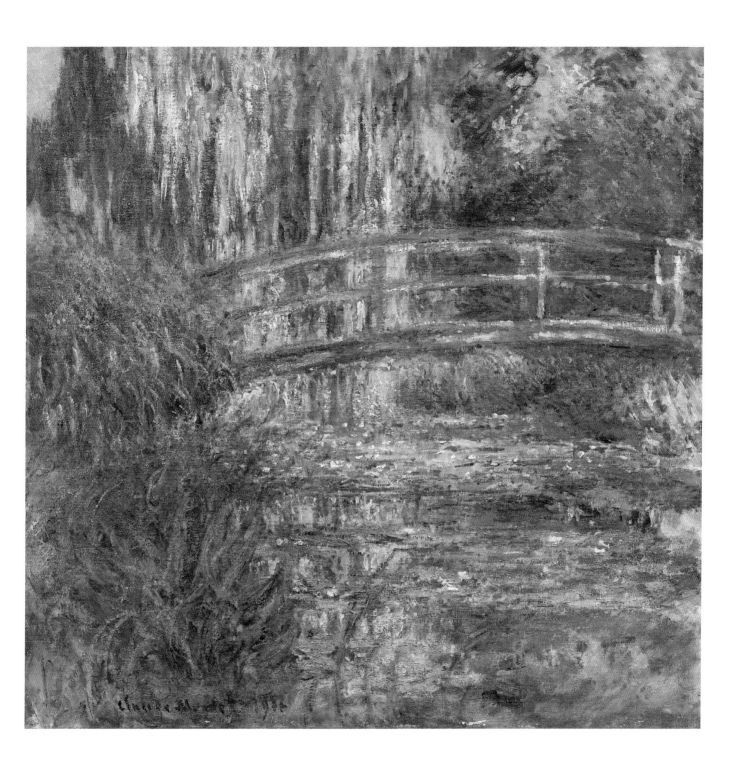

76. *The Water Lily Pond,* 1900.
Claude Monet (French, 1840–1926).
Oil on canvas, 90.2 × 92.7 cm (35½ × 36½ in.)

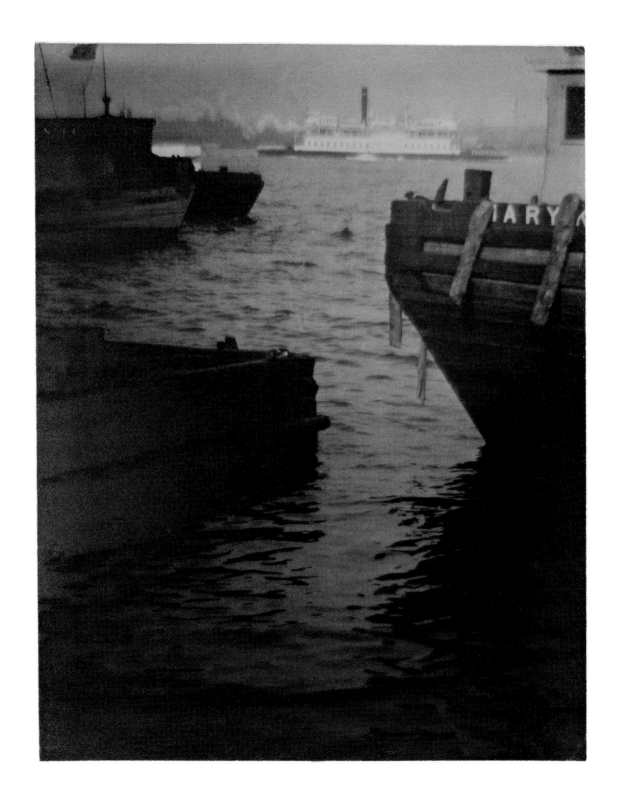

77. *On the East River, New York* (*White Ferry Boat*), 1909.
Karl Struss (American, 1886–1981). Photograph,
32.9 × 26 cm (12¹⁵⁄₁₆ × 10¼ in.)

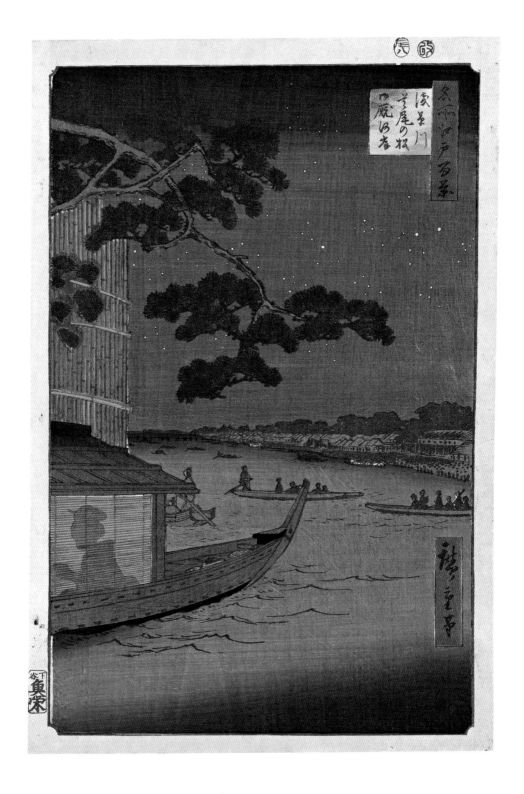

78. *Pine of Success and Oumayagashi, Asakusa River* from the series
One Hundred Famous Views of Edo, 1856. Utagawa Hiroshige (Japanese,
1797–1858). Woodblock print, 36.5 × 24.4 cm (14⅜ × 9⅝ in.)

79. *Flood Gates,* 1899. Frank Morley Fletcher
(English, 1866–1949). Woodcut, 20.6 × 25.3
cm (8⅛ × 9¹⁵⁄₁₆ in.)

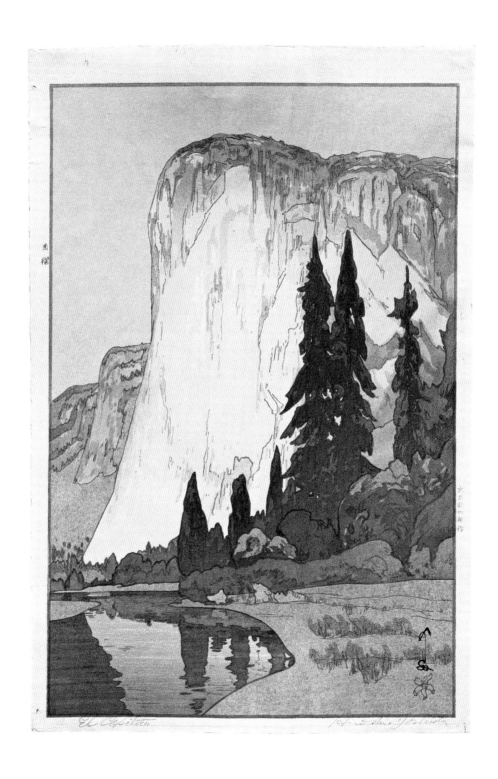

80. *El Capitan* from the series *The United States,* 1925.
Yoshida Hiroshi (Japanese, 1876–1950). Woodblock print,
40.2 × 26.7 cm (15¹³⁄₁₆ × 10½ in.)

NOTES

THE ALLURE OF JAPAN

1. Gabriel P. Weisberg et al., *Japonisme: Japanese Influence on French Art, 1854–1910* (Cleveland: Cleveland Museum of Art, 1975), 33.

2. The book of poetry has been identified by Sarah Thompson as *A New Collection of Comic Poems, One Each by Fifty Poets* (*Shinsen kyōka gojūnin isshu*).

3. Jean-Paul Bouillon, "A Gauche: Note sure la Société du Jing-Lar et sa signification," *Gazette des Beaux-Arts* 1310 (March 1978): 107–118; Bernard Bumpus, "The 'Jing-lar' and Republication Politics: Drinking, Dining, and *Japonisme*," *Apollo* 143 (March 1996): 13–16.

4. For more on stencils, see Susanna Kuo et al., *Carved Paper: The Art of the Japanese Stencil* (Santa Barbara, CA: Santa Barbara Museum of Art, 1998).

5. Charles Louis Tiffany, quoted in Hannah Sigur, *The Influence of Japanese Art on Design* (Salt Lake City: Gibbs Smith, 2008), 154.

6. William P. Hood Jr., "Western Dining Implements with Japanese *Kozuka* and *Kozuka* Style Handles," *The Magazine Antiques* 165 (January 2004): 142–151.

7. Ernest Chesneau, "Exposition universelle: Le Japon à Paris," *Gazette des Beaux-Arts* (July 1, 1878): 386.

8. Vincent van Gogh to Theo van Gogh, Arles, summer 1888, Letter 510, quoted in Ingo F. Walther and Rainer Metzger, *Vincent van Gogh: The Complete Paintings*, trans. Michael Hulse (Cologne: Taschen, 1993), 1:299.

9. Jason T. Busch and Catherine L. Futter, *Inventing the Modern World: Decorative Arts at the World's Fairs, 1851–1939*, ex. cat. (Pittsburgh: Carnegie Museum of Art; Kansas City, MO: The Nelson-Atkins Museum

of Art; in association with Skira Rizzoli, 2012), 129, 250.

10. Edmund de Waal, *The Hare with Amber Eyes: A Family's Century of Art and Loss* (New York: Farrar, Straus and Giroux, 2010), 53.

11. Anne Nishimura Morse, "Souvenirs of 'Old Japan': Meiji-Era Photography and the Meisho Tradition," in Sebastian Dobson et al., *Art & Artifice: Japanese Photographs of the Meiji Era* (Boston: MFA Publications, 2004), 49.

12. Arthur Wesley Dow, quoted in Frederick C. Moffatt, *Arthur Wesley Dow (1857–1922)*, ex. cat. (Washington, DC: Smithsonian Institution Press, 1977), 48–49.

13. Corinne Benson, quoted in Faith Andrews Bedford, *Frank W. Benson: American Impressionist* (New York: Rizzoli International, 1994), 163.

14. See Janet L. Comey, "Catalogue Entry 2: Frank Weston Benson, *Early Morning*," in *Impressionism Abroad: Boston and French Painting*, ex. cat. (London: Royal Academy of Arts, 2005), 106.

15. Frank Weston Benson, quoted in Bruce W. Chambers, "Frank W. Benson: Unity and Diversity in the Development of an Artistic Style," in Faith Andrews Bedford et al., *Frank W. Benson: A Retrospective* (New York: Berry-Hill Galleries, 1989), 154.

16. Beth Gates Warren, *Artful Lives: Edward Weston, Margrethe Mather, and the Bohemians of Los Angeles* (Los Angeles: J. Paul Getty Museum, 2011), 293.

FROM THE OTHER SIDE

1. Anne Yonemura, *Yokohama: Prints from Nineteenth-Century Japan* (Washington, DC: Arthur M. Sackler Gallery: Smithsonian Institution Press, 1990).

2. Timon Screech, *The Western Scientific Gaze and Popular Imagery in Later Edo Japan: The Lens within the Heart* (Cambridge: Cambridge University Press, 1996).

3. Kobayashi Tadashi, "Edo no Venus—Hattōshin no Kiyonaga bijin" ("The Venus of Edo: Kiyonaga's Eight-Head-Tall Beauties"), in Chiba City Art Museum, ed., *Torii Kiyonaga: The Birth of Venus in Edo* (Chiba City: Chiba City Art Museum, 2007), 8–12.

4. Anne Nishimura Morse et al., *Art of the Japanese Postcard* (Boston: MFA Publications, 2004).

WOMEN

1. Anna Marie Kirk, "Japonisme and Femininity: A Study of Japanese Dress in British and French Art and Society, c. 1860–c. 1899," *Costume* 42 (2008): 117.

2. Advertisement for "Japanese Silk-Dressing-Gowns and Jackets" from *Yuletide Gifts*, Christmas catalogue of Liberty and Company, 1898, reproduced in Akiko Fukai et al., *Fashion: A History from the 18th to the 20th Century, The Collection of the Kyoto Costume Institute*, vol. 1 (Cologne: Taschen, 2002), 306.

3. Richard Kendall and Jill DeVonyar, *Degas and the Art of Japan* (New Haven: Yale University Press, 2007), 11, 58–68.

4. Mary Cassatt, quoted in Barbara Shapiro, "Mary Cassatt's Color Prints and Contemporary French Printmaking," in *Mary Cassatt: The Color Prints* (New York: Harry N. Abrams in association with Williams College Museum of Art, 1989), 62. Italics reflect Cassatt's emphasis.

5. Claire Frèches-Thory believes that the drawing is a preliminary design for *The Desmarais Screen—Seamstresses*, 1893. Kunsthaus Zürich, *Die Nabis: Propheten*

der Moderne (Munich: Prestel, 1993), 392.

6. Linda Nochlin, *Women Artists: The Japanese Impulse* (Kyoto: Medieval Studies Institute, 2005).

7. Mabel Hyde, with illustrations by Helen Hyde, *Jingles from Japan* (San Francisco: A. M. Robertson, 1901).

CITY LIFE

1. Camille Pissarro to Lucien Pissarro, February 2 and 3, 1893, quoted in Alisa Bunbury, *From Paris with Love: The Graphic Arts in France, 1880s–1950s* (Melbourne: National Gallery of Victoria, 2004), 52.

2. Siegfried Wichmann, *Japonisme: The Japanese Influence on Western Art in the 19th and 20th Centuries* (1981; repr., New York: Park Lane, 1985), 34–35.

3. William James Homer, *Robert Henri and His Circle* (Ithaca, NY: Cornell University Press, 1969), 75.

4. Wichmann, *Japonisme,* 251.

5. David W. Kiehl, *American Art Posters of the 1890s* (New York: The Metropolitan Museum of Art, 1987), 182.

NATURE

1. Siegfried Bing, quoted in Klaus Berger, *Japonisme in Western Painting from Whistler to Matisse,* trans. David Britt (Cambridge: Cambridge University Press, 1992), 92.

2. Lucien Falize [M. Josse, pseud.], "L'Art japonais," *Revue des arts décoratifs* 3 (1882–1883): 363.

3. Arthur Wesley Dow, *Composition* (Garden City, NY: Doubleday, Page, 1919), 54.

4. Petra ten-Doesschate Chu, "Chinoiserie and Japonisme," in *The Orient Expressed: Japan's Influence on Western Art, 1854–1918,* ed. Gabriel P. Weisberg (Jackson: Mississippi Museum of Art, 2011), 95–105.

LANDSCAPE

1. Théodore Duret, quoted in Virginia Spate et al., *Monet and Japan,* ex. cat. (Canberra, Australia: National Gallery of Australia, 2001), 2.

2. Gustave Geffroy, quoted in Klaus Berger, *Japonisme in Western Painting from Whistler to Matisse,* trans. David Britt (Cambridge: Cambridge University Press, 1992), 191.

3. Emil Orlik, quoted in Siegfried Wichmann, *Japonisme: The Japanese Influence on Western Art in the 19th and 20th Centuries* (1981; repr., New York: Park Lane, 1985), 234.

4. J. A. M. Whistler, *Ten O'Clock* (Boston and New York: Houghton, Mifflin and Company, 1888), 29.

5. Claude Monet in conversation with Roger Marx, 1909, quoted in Berger, *Japonisme in Western Painting,* 312.

6. Julia Meech and Gabriel P. Weisberg, *Japonisme Comes to America: The Japanese Impact on the Graphic Arts, 1876–1925,* ex. cat. (New York: Harry N. Abrams, 1990), 222.

7. Eugene M. Skibbe, "The American Travels of Yoshida Hiroshi," *Andon* 43 (January 1993): 59–74.

1. *First Landing of Americans in Japan*, 1855
William Heine (American, born in Germany, 1827–1885)
Lithograph, hand colored
62.5 × 87.3 cm (24⅝ × 34⅜ in.)
Gift of Maxim Karolik for the M. and M. Karolik Collection of American Watercolors and Drawings, 1800–1875
56.404

2. *Fish* from the book *Hokusai Sketchbooks, Volume Two (Hokusai manga nihen)*, Edo period, about 1815–1868
Katsushika Hokusai (Japanese, 1760–1849)
Text by Rokujuen
Published by Eirakuya Tōshirō (Tōhekidō)
Woodblock-printed book; ink and limited color on paper
22.6 × 15.6 cm (8⅞ × 6⅛ in.)
Source unidentified 1997.837

3. *Fish Patterns for the Service Rousseau*, 1866
Félix Bracquemond (French, 1833–1914)
Etching
35 × 25 cm (13¾ × 9¹³⁄₁₆ in.)
Lee M. Friedman Fund, 1993 1993.100

4. Title page from the portfolio *Japonisme*, 1883
Félix H. Buhot (French, 1847–1898)
Etching, printed in red ink
26.1 × 17.6 cm (10¼ × 6¹⁵⁄₁₆ in.)
The Frederick Keppel Memorial Prints, gift of David Keppel M25228

5. *White Heron and Iris*, Edo period, 1830s
Utagawa Hiroshige (Japanese, 1797–1858)
Woodblock print; ink and color on paper
37.3 × 16.3 cm (14¹¹⁄₁₆ × 6⁷⁄₁₆ in.)
Gift of Miss Lucy T. Aldrich 47.130

6. Inkstand, 1876
Designed by Paul Legrand (French, 1840–1910)
Manufactured by the firm of Frédéric Boucheron, Paris
Silver, partial gilt, champlevé, basse-taille, cloisonné enamels
23.4 × 33.6 cm (9¼ × 13¼ in.)
Museum purchase with funds bequeathed by Genevieve Gray Young in memory of Patience Young and Patience Gray Young, Frederick Brown Fund, William E. Nickerson Fund, Otis Norcross Fund, Arthur Tracy Cabot Fund, H. E. Bolles Fund, Russell B. and Andrée Beauchamp Stearns Fund, Ernest Kahn Fund, Helen B. Sweeney Fund, and European Decorative Arts Insurance, Deaccession and Deaccession Income Funds 2000.977.1–7

7. Sword guard with design of insects, Edo period, late 18th–early 19th century
Hirata Narisuke (Japanese, died in 1816)
Copper and gold alloy (shakudō) with enamels and gold
7.1 × 6.3 × 0.4 cm (2¾ × 2½ × ¼ in.)
William Sturgis Bigelow Collection
11.11677

8. Textile stencil
Japan, Edo period–Meiji era, 19th century
Cut mulberry paper
25.7 × 40.5 cm (10⅛ × 15¹⁵⁄₁₆ in.)
William Sturgis Bigelow Collection
RES.11.748

9. Knives with kozuka-style handles, about 1881
Manufactured by the Gorham Manufacturing Company, Providence, RI
Silver with gilding
Each knife: 19.7 × 2 cm (7¾ x ¾ in.)
Museum purchase with funds by

exchange from a Gift of Harold Whitworth Pierce, Bequest of Maury A. Bromsen, Gift of Penelope Noyes, Gift of Richard Edwards, Gift of Mrs. Henrietta Page, Gift of Bloomingdale's, Bequest of Helen S. Coolidge, Bequest of Mrs. Edward Jackson Holmes, Gift of Mrs. Bradley Dewey, Bequest of Sarah E. Montague, American Decorative Arts Curator's Fund, Gift of the Estate of Ruth A. Safford, Bequest of Mrs. Charles R. Codman, and Bequest of Charles Hitchcock Tyler, Bequest of Mrs. Edna H. Howe, 2008 2008.76.3, 2008.76.9, 2008.76.12

10. Seacoast at Trouville, 1881
Claude Monet (French, 1840–1926)
Oil on canvas
60.7 × 81.3 cm (23⅞ × 32 in.)
The John Pickering Lyman Collection— Gift of Miss Theodora Lyman 19.1314

11. Yokkaichi: Mie River from the series Fifty-three Stations of the Tōkaidō Road, Edo period, about 1833–1834
Utagawa Hiroshige (Japanese, 1797–1858)
Woodblock print; ink and color on paper
Published by Takenouchi Magohachi (Hoeidō)
25.2 × 37 cm (9¹⁵⁄₁₆ × 14⁹⁄₁₆ in.)
William Sturgis Bigelow Collection
11.30171

12. Postman Joseph Roulin, 1888
Vincent van Gogh (Dutch, worked in France, 1853–1890)
Oil on canvas
81.3 × 65.4 cm (32 × 25¾ in.)
Gift of Robert Treat Paine, 2nd 35.1982

13. Actor Onoe Matsusuke II as the Carpenter Rokusaburō from the series Great Hit Plays, Edo period, about 1814

Utagawa Kunisada (Japanese, 1786–1864)
Published by Kawaguchiya Uhei
(Fukusendō)
Woodblock print; ink and color on paper
38.9 × 25.9 cm (15⁵⁄₁₆ × 10³⁄₁₆ in.)
William Sturgis Bigelow Collection
11.15140

14. *Five Swans,* 1897
Designed by Otto Eckmann (German,
1865–1902)
Woven by the Kunstgewerbeschule
Scherrebek
Wool and cotton tapestry
241.3 × 107.3 cm (95 × 42¼ in.)
Otis Norcuss Fund, Textile Curator's Fund,
Charles Potter Kling Fund, and Textile
Purchase Fund 1991.440

15. *Water* from the series *The Elements,*
1898
Gisbert Combaz (Belgian, 1869–1941)
Published by Dietrich et Cie
Postcard; chromlithograph
9 × 14 cm (3⁹⁄₁₆ × 5½ in.)
Bought for the Museum in Europe by
Sylvester Rosa Koehler M15180.9

16. *Carp Banners in Kyoto (Fête des Garçons),*
1888
Louis Dumoulin (French, 1860–1924)
Oil on canvas
46 × 54.3 cm (18⅛ × 21⅜ in.)
Fanny P. Mason Fund in memory of Alice
Thevin 1986.582

17. *View of Shijō-dori, Kyoto,* about 1886
Adolfo Farsari (Italian, 1841–1898)
Photograph; hand-tinted albumen print
19.2 × 24.2 cm (7⁹⁄₁₆ × 9½ in.)
Gift of Jean S. and Frederic A. Sharf
2004.270.32

18. *Suidō Bridge and Surugadai* from the
series *One Hundred Famous Views of Edo,* Edo
period, 1857
Utagawa Hiroshige (Japanese, 1797–1858)
Published by Uoya Eikichi
Woodblock print; ink and color on paper
35.7 × 24.5 cm (14¹⁄₁₆ × 9⅝ in.)
William Sturgis Bigelow Collection
11.36876.34

19. *Wall Enclosing the Mausoleum of Ieyasu at
Nikko, Japan,* 1897
Henry Roderick Newman (American,
1843–1917)
Watercolor over graphite on paper,
mounted on a wooden panel
41.9 × 48.3 cm (16½ × 19 in.)
General Funds, 1899 99.143

20. *Bend of a River,* about 1898
Arthur Wesley Dow (American, 1857–1922)
Woodcut, printed in color
23 × 6.1 cm (9¹⁄₁₆ × 2⅜ in.)
Gift of Mrs. Ethelyn H. Putnam 41.716

21. *Early Morning,* about 1899
Frank Weston Benson (American, 1862–
1951)
Oil on canvas
61.3 × 152.7 cm (24⅛ × 60⅛ in.)
Bequest of Dr. Arthur Tracy Cabot 13.2908

22. *Geese over a Beach,* Edo period, 18th
century
Maruyama Ōkyo (Japanese, 1733–1795)
Ink on paper
176.7 × 372 cm (69⅝ × 146½ in.)
Freer Gallery of Art, Smithsonian
Institution, Washington, D.C.
Gift of Charles Lang Freer F1898.143

23. *Prologue to a Sad Spring,* 1920
Edward Weston (American, 1886–1958)

Photograph; platinum-palladium print
23.8 × 18.7 cm (9⅜ × 7⅜ in.)
The Lane Collection

24. *Foreign Woman, Heron in a Willow Tree, Englishman Riding a Horse* from the series *Cutout Pictures of Many Lands*, Edo period, 1861
Utagawa Yoshiiku (Japanese, 1833–1904)
with Miyagi Gengyo (Japanese, 1817–1880)
Published by Maruya Tetsujirō (Enjudō)
Woodblock print; ink and color on paper
35.8 × 24.2 cm (14⅛ × 9½ in.)
Jean S. and Frederic A. Sharf Collection
2000.305

25. *Southern Barbarians at a Japanese Port*
Japan, Edo period, first half of the 17th century
One of a pair of six-panel folding screens; ink, color, and gold on paper
154.5 × 346 cm (60¹³⁄₁₆ × 136¼ in.)
Fenollosa-Weld Collection 11.4169

26. *Outside a Kabuki Theater in Sakai-chō* from an untitled series of Customs of the Twelve Months, Edo period, about 1705–1706
Okumura Masanobu (Japanese, 1686–1764)
Published by Sudō Gonbei
Woodblock print; ink and hand-applied color on paper
27.2 × 37.8 cm (10¹¹⁄₁₆ × 14⅞ in.)
Denman Waldo Ross Collection 06.845.11

27. *A Bookstore at New Year* from the book *Colors of the Triple Dawn (Saishiki mitsu no asa)*, Edo period, 1787
Torii Kiyonaga (Japanese, 1752–1815)
Published by Nishimuraya Yohachi (Eijudō)
Woodblock-printed book; ink and color on paper
25.5 × 19.3 cm (10¹⁄₁₆ × 7⅝ in.)

Nellie Parney Carter Collection—Bequest of Nellie Parney Carter 34.395

28. *Archery Contest at the Sanjūsangendō*, Edo period, about 1759
Maruyama Ōkyo (Japanese, 1733–1795)
Woodblock print; ink and hand-applied color on paper
20.9 × 27.2 cm (8¼ × 10¹¹⁄₁₆ in.)
Denman Waldo Ross Collection 11.1868

29. *Plum Estate, Kameido* from the series *One Hundred Famous Views of Edo*, Edo period, 1857
Utagawa Hiroshige (Japanese, 1797–1858)
Published by Uoya Eikichi
Woodblock print; ink and color on paper
37 × 25.2 cm (14⁹⁄₁₆ × 9¹⁵⁄₁₆ in.)
William Sturgis Bigelow Collection
11.35818

30. *Autumn Moon at Ishiyama Temple: Hinazuru of the Chōjiya* from an untitled series of courtesans for the Eight Views of Ōmi, Edo period, about 1800
Rekisentei Eiri (Japanese, active about 1781–1818)
Published by Yamaguchiya Chūemon (Chūsuke)
Woodblock print; ink and color on paper
39.5 × 35.1 cm (15⁹⁄₁₆ × 13¹³⁄₁₆ in.)
William Sturgis Bigelow Collection
11.15008

31. *Proportions of a Human Figure* from the book *Abbreviated Sketches of People (Jinbutsu Ryakuga shiki)*, Edo period, 1795
Kitao Masayoshi (Japanese, 1764–1824)
Woodblock-printed book; ink and color on paper
26.4 × 18.8 cm (10⅜ × 7⁷⁄₁₆ in.)
Gift of Arthur and Charlotte Vershbow
1993.700

32. *Student*, Meiji era, about 1900–1910
Kajita Hanko (Japanese, 1870–1917)
Published by the Association of Practical
Design (Jitsugyō zuan kai)
Postcard; lithograph, ink, and metallic
pigment on card stock with embossed
texture
13.8 × 8.8 cm (5⁷⁄₁₆ × 3⁷⁄₁₆ in.)
Leonard A. Lauder Collection of Japanese
Postcards 2002.965

33. *Courtesan in the Snow at the New Year*,
Edo period, 1804–1818
Kubo Shunman (Japanese, 1757–1820)
Hanging scroll; ink and color on silk
Image: 96.2 × 32.1 cm (37⁷⁄₈ × 12⁵⁄₈ in.)
Fenollosa-Weld Collection 11.4628

34. *Meditation*, about 1872
Alfred Stevens (Belgian, worked in France,
1823–1906)
Oil on canvas
40.7 × 32.4 cm (16 × 12¾ in.)
Bequest of David P. Kimball in memory of
his wife Clara Bertram Kimball 23.528

35. Woman's dressing gown
Japan, for the Western market, about 1900
Retailed by Takashimaya
Silk plain weave (taffeta) embroidered
with silk, silk plain weave lining, cord and
tassel trim
Center back length: 141 cm (55½ in.)
Gift of Elizabeth Ann Coleman
2001.933.1–2

36. *The Prodigal Son: In Foreign Climes*, 1881
James Jacques Joseph Tissot (French,
1836–1902)
Etching and drypoint
30.9 × 37.3 cm (12³⁄₁₆ × 14¹¹⁄₁₆ in.)
Gift of George A. Goddard M28011

37. *Mary Cassatt at the Louvre: The Etruscan
Gallery*, 1879–1880
Edgar Degas (French, 1834–1917)
Soft-ground etching, drypoint, aquatint,
and etching
26.7 × 23.2 (10½ × 9⅛ in.)
Katherine E. Bullard Fund in memory of
Francis Bullard, by exchange 1983.310

38. *Yatsuhashi* from the series *Fashionable
Tales of Ise*, Edo period, about 1814–1817
Kikugawa Eizan (Japanese, 1787–1867)
Published by Tsuruya Kiemon (Senkakudō)
Woodblock print; ink and color on paper
38.3 × 25 cm (15¹⁄₁₆ × 9¹³⁄₁₆ in.)
Gift of the Estate of Henry Adams 20.85

39. *Maternal Caress*, about 1902
Mary Stevenson Cassatt (American,
1844–1926)
Oil on canvas
92 × 73.3 cm (36¼ × 28⅞ in.)
Gift of Miss Aimée Lamb in memory of Mr.
and Mrs. Horatio Appleton Lamb 1970.252

40. *Otome* from the series *Eastern Figures
Matched with the Tale of Genji*, Edo period,
about 1818–1823
Kikugawa Eizan (Japanese, 1787–1867)
Published by Mikawaya Den'emon
Woodblock print; ink and color on paper
37.4 × 25.1 cm (14¾ × 9⅞ in.)
William Sturgis Bigelow Collection
11.17766

41. *English Woman*, 1899
Emil Orlik (Czech, worked in Germany,
1870–1932)
Woodcut, printed in black and brown
20.8 × 16.9 cm (8³⁄₁₆ × 6⅝ in.)
Lee M. Friedman Fund 2009.2309

42. *Courtesan as Fei Zhangfang* from a series of courtesans imitating Taoist immortals, Edo period, about 1706–1708
Okumura Masanobu (Japanese, 1686–1764)
Published by Igaya
Woodblock print; ink on paper
28.9 × 40 cm (11⅜ × 15¹³⁄₁₆ in.)
Gift of Mrs. Jared K. Morse in memory of Charles J. Morse 53.2923

43. *Child and Nurse in the Garden. Project for a Screen.*, about 1892
Edouard Vuillard (French, 1868–1940)
Drawing; ink and watercolor over graphite
20 × 30.8 cm (7⅞ × 12⅛ in.)
Rose-Marie & Eijk van Otterloo Collection

44. *Family Umbrella*, 1915
Helen Hyde (American, 1868–1919)
Woodcut, printed in color
20.5 × 16.7 cm (8¹⁄₁₆ × 6⁹⁄₁₆ in.)
Gift of Azita Bina-Seibel and Elmar W. Seibel 1991.795

45. *Courtiers Preparing for a Performance* from the book *Hokusai Sketchbooks, Volume Twelve* (*Hokusai manga jūnihen*), Edo period, 1834
Katsushika Hokusai (Japanese, 1760–1849)
Published by Eirakuya Tōshirō
Woodblock-printed book; ink on paper
22.7 × 15.6 cm (8¹⁵⁄₁₆ × 6⅛ in.)
Gift of Mrs. Jared K. Morse in memory of Charles J. Morse 1997.871

46. *Caudieux—Petit Casino* from the portfolio *Le Café Concert*, 1893
Henri de Toulouse-Lautrec (French, 1864–1901)
Lithograph, printed in black ink
26.9 × 20.8 cm (10⁹⁄₁₆ × 8³⁄₁₆ in.)
Bequest of W. G. Russell Allen 60.757

47. *The Jockey*, 1899
Henri de Toulouse-Lautrec (French, 1864–1901)
Lithograph, printed in color
51.4 × 35.7 cm (20¼ × 14¹⁄₁₆ in.)
Fund in memory of Horatio Greenough Curtis 24.1704

48. *Painted Horse Escaping from Ema*, Edo period, 1834
Totoya Hokkei (Japanese, 1780–1850)
Woodblock print; ink and color on paper
20.3 × 18.1 cm (8 × 7⅛ in.)
William Sturgis Bigelow Collection 11.25469

49. *The Square at Evening* from the series *Some Scenes of Parisian Life*, about 1897–1898
Pierre Bonnard (French, 1867–1947)
Published by Ambroise Vollard (French, 1867–1939)
Lithograph, printed in color
27.9 × 38.1 cm (11 × 15 in.)
Bequest of W. G. Russell Allen 60.58

50. *Hunting* from *An Almanac of Twelve Sports*, 1897
William Nicholson (English, 1872–1949)
Woodcut, printed in color and hand colored
19.9 × 20 cm (7¹³⁄₁₆ × 7⅞ in.)
Gift of Francis Bullard M22343.1

51. *Sidewalk Café*, about 1899
Robert Earle Henri (American, 1865–1929)
Oil on canvas
81.6 × 65.7 cm (32⅛ × 25⅞ in.)
Emily L. Ainsley Fund 59.657

52. *Flowers of Spring*, 1924
John Sloan (American, 1871–1951)
Oil on canvas

76.5 × 63.8 cm (30⅛ × 25⅛ in.)
Gift of Miss Amelia E. White 67.1162

53. *The Century*, July 1895
Charles Herbert Woodbury (American,
1864–1940)
Poster; lithograph, printed in color
44.5 × 26.1 cm (17½ × 10¼ in.)
Gift of Wheaton Holden 1971.128

54. *Kinryūzan Temple, Asakusa* from the
series *One Hundred Famous Views of Edo*,
Edo period, 1856
Utagawa Hiroshige (Japanese, 1797–1858)
Published by Uoya Eikichi
Woodblock print; ink and color on paper
33.5 × 21.8 cm (13³⁄₁₆ × 8⁹⁄₁₆ in.)
William Sturgis Bigelow Collection 11.16695

55. *Illustration of the Opening Ceremony of the
Union Horse Racing Club's Racetrack around
Shinobazu Pond in Ueno Park*, Meiji era, 1884
Hashimoto Chikanobu (Japanese, 1838–
1912)
Published by Ōkura Magobei
Woodblock print; ink and color on paper
36.9 × 74.3 cm (14½ × 29¼ in.)
William Sturgis Bigelow Collection
11.18168–70

56. *Still Life with Azaleas and Apple Blossoms*,
1878
Charles Caryl Coleman (American, 1840–
1928)
Oil on canvas
180.3 × 62.9 cm (71 × 24.7 in.)
Charles H. Bayley Picture and Painting
Fund, Paintings Department Special Fund,
American Paintings Deaccession Fund, and
Museum purchase with funds donated
by William R. Elfers Fund, an anonymous
donor, Mr. and Mrs. E. Lee Perry, Jeanne
G. and Stokley P. Towles, Mr. Robert M.

Rosenberg and Ms. Victoria DiStefano, Mr.
and Mrs. John Lastavica, and Gift of Dr.
Fritz B. Talbot and Museum purchase with
funds donated by Mrs. Charles Gaston
Smith's Group, by exchange 2001.255

57. *Shells* from the book *Gifts from the Ebb
Tide* (*Shiohi no tsuto*), Edo period, 1789
Kitagawa Utamaro (Japanese, died in 1806)
Woodblock-printed book; ink, color, mica,
and brass dust on paper
27.2 × 19.1 cm (10¹¹⁄₁₆ × 7½ in.)
William S. and John T. Spaulding Collection
1997.953

58. Box with palmetto design for writing
paper, Edo period, 17th to 18th century
Attributed to Ogawa Haritsu (Japanese,
1663–1747)
Paulownia with lacquer and inlaid
decoration
11.2 × 23.8 × 28.5 cm (4⅜ × 9⅜ × 11¼ in.)
Museum purchase with funds donated by
contribution 08.170a-b

59. Tea set, 1874–1875
Marked by Frederick Elkington (English,
1887–1963)
Manufactured by Elkington and Company,
Birmingham, England
Silver, gilded silver, baleen
Tray: 24.6 × 44.1 cm (9¾ × 17⅜ in.)
Teapot: 11.8 × 16.7 cm (4⅝ × 6⅝ in.)
Sugar bowl: 7.9 × 12.9 cm (3⅛ × 5⅛ in.)
Cream jug: 8.1 × 8.3 cm (3 × 3¼ in.)
Gift of Mrs. Frederick T. Bradbury, by
exchange 1991.539–542

60. *Butterfly and Peonies*, Edo period, about
1830
Katsukawa Shunkō II (Japanese, 1762–
about 1830)
Woodblock print; color on paper

22.2 × 15.5 cm (8¾ × 6⅛ in.)
Gift of Porter Sargent 49.1276

61. Jardinière, about 1883
Manufactured by Minton and Company,
England
Probably after a model by Christopher
Dresser (English, 1834–1904)
Glazed earthenware
45.7 × 53.3 × 44.5 cm (18 × 21 × 17½ in.)
Benjamin Pierce Cheney Fund 2010.609

62. *Bradley: His Book*, 1896
William H. Bradley (American, 1868–1962)
Woodcut and lithograph, printed in color
106.2 × 74 cm (41¹³⁄₁₆ × 29⅛ in.)
Lee M. Friedman Fund 69.1152

63. *Lotus*, about 1900
Arthur Wesley Dow (American, 1857–1922)
Photograph; cyanotype
20.3 × 12.7 cm (8 × 5 in.)
Gift of Philio Wigglesworth Cushing and
Henry Coolidge Wigglesworth from the
collection of their parents Frank and Anne
Wigglesworth in memory of their love
for Ipswich. M. and M. Karolik Fund and
Charles H. Bayley Picture and Painting
Fund 2006.1277.112

64. *Summer Flowers*, 1920s
Margaret Jordan Patterson (American,
born in Java, 1867–1950)
Woodcut, printed in color
25.5 × 17.8 cm (10¹⁄₁₆ × 7 in.)
Gift of Howard Leavitt Horton 46.863

65. *Design of Peonies and Chrysanthemums*
Japan, Edo period, 1866
Woodblock print; ink and color on paper
38 × 25.7 cm (14¹⁵⁄₁₆ × 10⅛ in.)
William Sturgis Bigelow Collection 11.39403

66. *Still Life with Sea Shells*, 1923
James Ensor (Belgian, 1860–1949)
Oil on paperboard, mounted on a cradled
wooden panel
44.5 × 55 cm (17½ × 21⅝ in.)
Gift of G. Peabody Gardner 60.124

67. *Blue Aurene* fan vase, about 1927
Designed by Frederick C. Carder
(American, born in England, 1863–1963)
Manufactured by the Steuben Division of
Corning Glass Works, Corning, NY
Iridized lead glass with applied ornament
21.6 × 17.8 × 10.2 cm (8½ × 7 × 4 in.)
Gift of The New Bedford Glass Society, Inc.,
1992 1992.84

68. *A Hillside Study (Two Trees)*, about 1862
John La Farge (American, 1835–1910)
Oil on canvas
61 × 32.7 cm (24 × 12⅞ in.)
William Sturgis Bigelow Collection 26.771

69. *Hodogaya on the Tōkaidō* from the series
Thirty-six Views of Mount Fuji, Edo period,
about 1830–1831
Katsushika Hokusai (Japanese, 1760–1849)
Published by Nishimuraya Yohachi (Eijudō)
Woodblock print; ink and color on paper
25.5 × 36.8 cm (10¹⁄₁₆ × 14½ in.)
William Sturgis Bigelow Collection
11.17541

70. *Pine Forest (Tannenwald)*, mid-1890s
Peter Behrens (German, 1868–1940)
Woodcut, printed in color
27 × 15.2 cm (10⅝ × 6 in.)
Harvey D. Parker Collection P3688

71. *Summer Night's Dream (The Voice)*, 1893
Edvard Munch (Norwegian, 1863–1944)
Oil on canvas
87.9 × 108 cm (34⅝ × 42½ in.)

Ernest Wadsworth Longfellow Fund
59.301

72. *Landscape with Two Breton Women,* 1889
Paul Gauguin (French, 1848–1903)
Oil on canvas
72.4 × 91.4 cm (28½ × 36 in.)
Gift of Harry and Mildred Remis and
Robert and Ruth Remis 1976.42

73. *Working in the Fields,* 1906
Henri Rivière (French, 1864–1951)
Lithograph, printed in color
37.7 × 50 cm (14¹³⁄₁₆ × 19¹¹⁄₁₆ in.)
Lee M. Friedman Fund 1984.254

74. *Nocturne: Palaces* from the group *Second Venice Set,* 1879–1880
James Abbott McNeill Whistler (American, worked in England, 1834–1903)
Etching and drypoint
29.5 × 20 cm (11⅝ × 7⅞ in.)
Anonymous gift 59.818

75. *Bamboo Yards, Kyōbashi Bridge* from the series *One Hundred Famous Views of Edo,* Edo period, 1857
Utagawa Hiroshige (Japanese, 1797–1858)
Published by Uoya Eikichi
Woodblock print; ink and color on paper
37 × 25.2 cm (14⁹⁄₁₆ × 9¹⁵⁄₁₆ in.)
William Sturgis Bigelow Collection 11.26350

76. *The Water Lily Pond,* 1900
Claude Monet (French, 1840–1926)
Oil on canvas
90.2 × 92.7 cm (35½ × 36½ in.)
Given in memory of Governor Alvan T.
Fuller by the Fuller Foundation 61.959

77. *On the East River, New York (White Ferry Boat),* 1909
Karl Struss (American, 1886–1981)

Photograph; palladium print
32.9 × 26 cm (12¹⁵⁄₁₆ × 10¼ in.)
Gift of David Bakalar 1977.676

78. *Pine of Success and Oumayagashi, Asakusa River* from the series *One Hundred Famous Views of Edo,* Edo period, 1856
Utagawa Hiroshige (Japanese, 1797–1858)
Published by Uoya Eikichi
Woodblock print; ink and color on paper
36.5 × 24.4 cm (14⅜ × 9⅝ in.)
William Sturgis Bigelow Collection
11.45666

79. *Flood Gates,* 1899
Frank Morley Fletcher (English, 1866–1949)
Woodcut, printed in color
20.6 × 25.3 cm (8⅛ × 9¹⁵⁄₁₆ in.)
Bought of John D. Batten, London M15196

80. *El Capitan* from the series *The United States,* Taishō era, 1925
Yoshida Hiroshi (Japanese, 1876–1950)
Woodblock print; ink and color on paper
40.2 × 26.7 cm (15¹³⁄₁₆ × 10½ in.)
Gift of L. Aaron Lebowich 50.2943

FURTHER READING

Benfey, Christopher. *The Great Wave: Gilded Age Misfits, Japanese Eccentrics, and the Opening of Old Japan.* New York: Random House, 2004.

Berger, Klaus. *Japonisme in Western Painting from Whistler to Matisse.* Translated by David Britt. Cambridge, UK: Cambridge University Press, 1992.

Breuer, Karin. *Japanesque: The Japanese Print in the Era of Impressionism.* Ex. cat. San Francisco: Fine Arts Museums of San Francisco; Munich: Prestel, 2010.

Davis, Elliot Bostwick, et al. *A New World Imagined: Art of the Americas.* Boston: MFA Publications, 2010, esp. "Asia," pp. 291–319.

DeVonyar, Jill, and Richard Kendall. *Degas and the Art of Japan.* Ex. cat. Reading, PA: Reading Public Museum, 2007.

de Waal, Edmund. *The Hare with Amber Eyes: A Family's Century of Art and Loss.* New York: Farrar, Straus and Giroux, 2010.

Foxwell, Chelsea, et al. *Awash in Color: French and Japanese Prints.* Ex. cat. Chicago: Smart Museum of Art, University of Chicago, 2012.

Galeries nationales du Grand Palais. *Le Japonisme.* Ex. cat. Paris: Editions de la Réunion des musées nationaux, 1988.

Ives, Colta Feller. *The Great Wave: The Influence of Japanese Woodcuts on French Prints.* New York: Metropolitan Museum of Art, 1974.

Kobayashi, Tadashi. *Ukiyo-e: An Introduction to Japanese Woodblock Prints*. Translated by Mark A. Harbison. Tokyo and New York: Kodansha International, 1982.

Meech, Julia. *Frank Lloyd Wright and the Art of Japan: The Architect's Other Passion*. New York: Harry N. Abrams, 2001.

Meech, Julia, and Gabriel P. Weisberg. *Japonisme Comes to America: The Japanese Impact on the Graphic Arts, 1876–1925*. Ex. cat. New York: Harry N. Abrams, 1990.

Munroe, Alexandra. *The Third Mind: American Artists Contemplate Asia, 1860–1989*. Ex. cat. New York: Guggenheim Museum Publications, 2009.

Rappard-Boon, Charlotte van, et al. *Catalogue of the Van Gogh Museum's Collection of Japanese Prints*. Amsterdam: Van Gogh Museum; Zwolle: Waanders Publishers, 1991.

Sigur, Hannah. *The Influence of Japanese Art on Design*. Salt Lake City: Gibbs Smith, 2008.

Spate, Virginia, et al. *Monet and Japan*. Ex. cat. Canberra, Australia: National Gallery of Australia, 2001.

Swinbourne, Anna, et al. *James Ensor*. Ex. cat. New York: Museum of Modern Art, 2009.

Weisberg, Gabriel P. *The Orient Expressed: Japan's Influence on Western Art, 1854–1918*. Ex. cat. Jackson: Mississippi Museum of Art, 2011.

Weisberg, Gabriel P., Edwin Becker, and Evelyne Possémé, eds. *The Origins of L'Art Nouveau: The Bing Empire*. Ex. cat. Amsterdam: Van Gogh Museum; Paris: Musée des Arts décoratifs; Antwerp: Mercatorfonds, 2004.

Weisberg, Gabriel P., et al. *Japonisme: Japanese Influence on French Art, 1854–1910*. Ex. cat. Cleveland: Cleveland Museum of Art, 1975.

Wichmann, Siegfried. *Japonisme: The Japanese Influence on Western Art in the 19th and 20th Centuries*. New York: Park Lane, 1985.

Yamada Chisaburō, ed. *Japonisme in Art: An International Symposium*. Tokyo: Committee for the Year 2001, 1980.

INDEX

MFA Publications
Museum of Fine Arts, Boston
465 Huntington Avenue
Boston, Massachusetts 02115
www.mfa.org/publications

Published in conjunction with the exhibition *Looking East*, organized by the Museum of Fine Arts, Boston.

Frist Center for the Visual Arts, Nashville, Tennessee
January 31–May 11, 2014

Setagaya Art Museum, Tokyo, Japan
June 28–September 15, 2014

Kyoto Municipal Museum of Art, Japan
September 30–November 30, 2014

Nagoya/Boston Museum of Fine Arts, Japan
January 2–May 10, 2015

Musée National des Beaux-Arts du Québec, Canada
June 11–September 27, 2015

Asian Art Museum, San Francisco, California
October 30, 2015–January 24, 2016

While the objects in this publication necessarily represent only a small portion of the MFA's holdings, the Museum is proud to be a leader within the American museum community in sharing the objects in its collection via its website. Currently, information about more than 330,000 objects is available to the public worldwide. To learn more about the MFA's collections, including provenance, publication, and exhibition history, kindly visit *www.mfa.org/collections*.

For a complete listing of MFA publications, please contact the publisher at the above address, or call 617 369 3438.

Front cover: Charles Herbert Woodbury, *The Century*, July 1895 (fig. 53, detail); back cover: Claude Monet, *The Water Lily Pond*, 1900 (fig. 76, detail); endpapers: Textile stencil, Japan, 19th Century (fig. 8, detail); p. 1: Arthur Wesley Dow, *Lotus*, about 1900 (fig. 63, detail); p. 2: Designed by Otto Eckman, *Five Swans*, 1897 (fig. 14, detail); pp. 4–5: Louis Dumoulin, *Carp Banners in Kyoto (Fête des Garçons)*, 1888 (fig. 16, detail); p. 6: Designed by Frederick C. Carder, *Blue Aurene* fan vase, about 1927 (fig. 67)

All illustrations in this book were photographed by the Imaging Studios, Museum of Fine Arts, Boston, except where otherwise noted.

Grateful acknowledgment is made to the copyright holders for permission to reproduce the following works: Pierre Bonnard, *The Square at Evening*, © 2013 Artists Rights Society (ARS), New York / ADAGP, Paris; James Ensor, *Still Life with Sea Shells*, © 2013 Artists Rights Society (ARS), New York / SABAM, Brussels; Edvard Munch, *Summer Night's Dream (The Voice)*, © 2013 The Munch Museum / The Munch-Ellingsen Group / Artists Rights Society (ARS), New York; Henri Rivière, *Working in the Fields*, © 2013 Artists Rights Society (ARS), New York / ADAGP, Paris; Yoshida Hiroshi, *El Capitan*, reproduced with permission.

Edited by Anna Barnet
Copyedited by Amanda Heller
Proofread by Kathryn Blatt
Designed by Steven Schoenfelder

Production by Terry McAweeney

Printed and bound at Verona Libri, Verona, Italy

Available through ARTBOOK | D.A.P.
155 Sixth Avenue, 2nd floor
New York, New York 10013
Tel.: 212 627 1999 | Fax: 212 627 9484

FIRST EDITION
Printed and bound in Italy
This book was printed on acid-free paper.